Die Pioniere der Photographie
1840 – 1900
Die Sammlung Robert Lebeck

The Pioneers of Photography
1840 – 1900
The Robert Lebeck Collection

Rainer Wick (Hg.)

Die Pioniere der Photographie
1840 – 1900
Die Sammlung Robert Lebeck

Einführung Carlo Bertelli

Rainer Wick (Ed.)

The Pioneers of Photography
1840 – 1900
The Robert Lebeck Collection

Introduction Carlo Bertelli

Weingarten

Umschlag:
William Edward Kilburn
England

Mutter und Tochter
Ca. 1850
Kolorierte Daguerreotypie,
1/4 Platte

Cover:
William Edward Kilburn
England

Mother and daughter
1850 ca.

*Coloured daguerreotype,
1/4 plate*

Dieses Buch entstand zur Ausstellung einer Auswahl von
Exponaten aus der Sammlung Robert Lebeck in der
Städtischen Galerie Erlangen, April und Mai 1989,
im Museum für Kunst und Gewerbe in Hamburg, August
und September 1989 und in der Galerie Jahrhunderthalle
Hoechst, Frankfurt, Oktober und November 1989.

Curators: Carlo Bertelli, Karl Manfred Fischer
Production: Rainer Wick
Design: Nicola Adami, Laura Massa und Gianluca Poletti

We would like to express our thanks to Ojars Baumeister,
Elke Dröscher, Karl Manfred Fischer, Michael Hocks,
Rüdiger Joppien, Robert Lebeck, Heinz Meffert, Herbert
Meyer-Ellinger, Angela & Filippo Passigli, Barbara Stürm,
whose kind collaboration allowed for the realization of this
exhibit.

CIP-Titelaufnahme der Deutschen Bibliothek

Die Pioniere der Photographie: 1840-1900; die Sammlung
Robert Lebeck = The pioneers of photography / Rainer Wick
(Hg.). Einf. Carlo Bertelli – Weingarten:
Kunstverlag Weingarten, 1989
Einheitssacht.: I pionieri della fotografia ‹dt.›
ISBN 3-8170-2502-5 (Museumsausg.) brosch.
ISBN 3-8170-2501-7 Pb.
NE: Wick, Rainer [Hrsg.]; PT; EST

© der Originalausgabe: Idea Books Edizioni, Milano 1988
© dieser Ausgabe: Kunstverlag Weingarten GmbH,
Weingarten 1989
Satz: Fotosatz F. Riedmayer GmbH, Weingarten
Reproduktionen: Grauwert (Abzüge),
Steffen Wolff (Photographien)
Gesamtherstellung: Freiburger Graphische Betriebe,
Freiburg
Printed in Germany
ISBN 3-8170-2501-7 (Pappband)
ISBN 3-8170-2502-5 (Museumsausgabe, broschiert)

Noch immer wird das Sammeln und die Präsentation der Photographie von den europäischen Kunst-Museen weitgehend vernachlässigt. Es war wohl der Doppelcharakter der Photographie als Medium der Kunst wie der Dokumentation, der eine so nachhaltige Verunsicherung ausgelöst hat. Andererseits wird die Kunst-Fähigkeit der Photographie und ihre künstlerische Bedeutung längst nicht mehr bestritten. Vor 150 Jahren wurde das Medium, das eine weltweite Kulturrevolution ausgelöst hat, entdeckt. Zum Jubiläumsjahr angekündigt ist eine Vielzahl von großen Ausstellungen, was vielleicht der Beginn sein könnte eines selbstverständlicheren Verhältnisses zwischen den Traditions-Künsten und dem künstlerischen Medium des Industrie-Zeitalters. In diesem „Jahr der Photographie" führt die Präsentation der Sammlung des Photographen Robert Lebeck in die Entdeckerzeit des Mediums. „Pioniere der Photographie" zeigt eine Auswahl von rund 300 zum Teil original gerahmten Photographien aus dieser außerordentlichen Privatsammlung. Die Ausstellung vereint mehrere Aspekte: sie gibt das Beispiel einer Sammlung von hoher Qualität, darüberhinaus vermittelt sie einen breiten Eindruck der photographischen Frühzeit, und schließlich schöpft sie aus dem Fundus, mit dem ein Photograph seine photographische Erfahrungswelt bereicherte. Die Sammlung wurde geprägt von Robert Lebecks persönlichen Neigungen, seiner fachlichen Neugier und seinem erfahrenen Auge. Zu sammeln begann Robert Lebeck, der zu den wichtigsten Vertretern des modernen Bildjournalismus gezählt wird, vor rund 15 Jahren, zunächst die früheste, später die Photographie bis zur Jahrhundertwende. Heute besteht seine Sammlung aus etwa 30 000 Photographien.
Die Ausstellung enthält Photos aus der Zeit von 1840 bis 1900 aus den verschiedensten Erdteilen. Photo-, Sozial-, Kunst- und politische Geschichte sind gleichermaßen dokumentiert. Belegt sind auch die technischen Entwicklungen der frühen Photographie.

Wenngleich die Sammlung nicht enzyklopädisch angelegt wurde, werden die großen Themen der frühen Photo-Geschichte deutlich: Bildnis und Landschaft, Vedute und Akt, Exotik und Katastrophe, Kunst- und Natur-Schönes. Die Bilder berichten von Biedermeier-Häuslichkeit und Abenteuer in fernen Ländern, von Kriegen und Revolutionen, von Staatsbesuchen und Regierungswechseln. Dahinter sichtbar werden — bisweilen unfreiwillig — aber auch die krassen sozialen Gegensätze der Zeit vor der Jahrhundertwende; der imperialistisch-kolonialistische Zugriff auf die Kontinente. Es manifestieren sich die Werte einer Welt im Umbruch, deren Pendel beständig zwischen rückwärtsgewandtem, verklärend-sentimentalem Romantizismus und progressiver, sachlich-empirischer Erfassung schwingt.

Die Ausstellung enthält all jene photographischen Ereignisse, die zu Inkunabeln unserer photographischen Erinnerung wurden, zum Beispiel John Fox Talbots erstaunte photographische Blicke auf den Alltag seiner Umgebung, Felix Nadars eindringliche Prominentenporträts, die Kriegsbilder von Roger Fenton und die Stadtansichten von Hermann Krone. Darüberhinaus aber wurden in vielen Fällen gerade auch Photos von den Nebenschauplätzen der „Haupt- und Staatsaktionen" für die Ausstellung zusammengestellt. Menschen, Dinge und Ereignisse, die man schon zu kennen meint, sieht man von einer ungewohnten Seite. Nachdem viele dieser Photographien zudem bisher nicht veröffentlicht worden sind, stellen sie auch eine Entdeckungsreise in die Vergangenheit dar, öffnen sich wie die Erde den frühen Reisenden einem unverbrauchten Blick, eine Rarität im Zeitalter des millionenfachen Reproduziertwerdens.

Karl Manfred Fischer

Sammeln, um zu wissen
von Carlo Bertelli

Vor 10 Jahren eröffnete Joseph Alsop, ein bekannter Kunsthistoriker und Kunstmarktexperte, seinen Vortrag vor einem ausgewählten Publikum, das sich in der Nationalgalerie in Washington D.C. zu einem der berühmten *Andrew W. Mellon Vorträge* zusammengefunden hatte, mit folgenden Bemerkungen: „Es mag Sie überraschen, daß es in den Vereinigten Staaten viele ernsthafte Sammler von Coca-Cola Flaschen gibt, darunter ihren eigenen Vasari und E.H. Gombrich zusammen in einer Person: Cecil Munsey, Autor des Buches *The Illustrated Guide to the Collectibles of Coca-Cola*. Eine „Hutchinson bottle", hergestellt vor der Einführung des Schraubverschlusses, kostet heute $ 200. Es mag Ihnen noch unglaublicher erscheinen, daß viele andere Amerikaner Stacheldraht sammeln. Sie unterstützen eine Zeitschrift über Stacheldraht; die Hauptthemen in *The Barbarian* (ein Wortspiel mit der amerikanischen Bezeichnung für Stacheldraht, „barbed wire", Anm. der Übers.) sind natürlich die Geschichte des Stacheldrahts und der Marktwert der selteneren Exemplare. Kurzum: unabhängig davon, wie merkwürdig die Schätze eines Sammlers sein mögen, das Sammeln allein kann nicht bestehen."
Mit diesen heiteren Beispielen wollte Joseph Alsop ein ernstes Thema einleiten: „Das Sammeln kann niemals losgelöst für sich allein existieren. Jede Form des Sammelns muß notwendigerweise neben der Geschichte des Sammelobjekts sowie dem Sammlermarkt bestehen." Alsops Beispiele aus verschiedenen Kunstbereichen und kunstgeschichtlichen Epochen verdeutlichen diesen Punkt. Stimmt seine Aussage für die Antiquitätensammlung von Rubens für die Muschelsammlung Rembrandts und für die vom Großherzog Leopoldo und Abt Lanzi geplanten Großsammlungen in der Galerie der Uffizien, so gilt sie genauso für die Sammlungen gänzlich neuer Objekte. Verfügt das Germanische Nationalmuseum in Nürnberg, für seine Sammlung von deutschem Kunsthandwerk aus dem Mittelalter und der Renaissance bekannt, jetzt über eine moderne Abteilung, die den industriellen Produkten vom Anfang dieses Jahrhunderts bis 1930 gewidmet ist, so ist dies der leidenschaftlichen Forschungsarbeit des Kunsthistorikers Tilmann Buddensieg zu verdanken, der die strenge Schule eines auf das Mittelalter spezialisierten Historikers durchgemacht hat. Bei der Arbeit in Bereichen, die uns weniger vertraut als Malerei oder Radierung sind, wie illuminierte Manuskripte, Bronzen aus der Renaissance oder Meißner Porzellan, muß der neue Sammler sich einen Plan der Objekte seiner Sammlung entwerfen, in dem er sie in ein räumliches und zeitliches Koordinatensystem zuordnet. Er legt fest, was als erstes und zweites kommt; er ermittelt entweder logische Kontinuitäten oder Brüche in der zeitlichen Reihenfolge, bestimmt durch Ereignisse, die zwar entscheidend sind, aber nicht unmittelbar mit den Entwicklungsstrukturen des gesammelten Objekts zusammenhängen. 1955 widmete Helmut Gernsheim das Schlußkapitel seines monumentalen Buchs *History of Photography* der „Notwendigkeit eines nationalen Museums und Instituts der Photographie". Gernsheim argumentierte, daß es zahlreiche öffentliche und private Sammlungen gibt, die sich mit photographieverwandten Bereichen befassen. Nur eine öffentliche Sammlung zum Zweck der Erhaltung interessanter Photographien der Vergangenheit und der Gegenwart für zukünftige Generationen wäre aber in der Lage, Dokumente vor der sonst vermeidbaren Zerstörung

Collecting for Knowledge
by Carlo Bertelli

Ten years ago, before a selected crowd gathered at the National Gallery in Washington D.C. for one of the famous *Andrew W. Mellon Lectures,* Joseph Alsop, well-known art historian and expert of the art market, began his lecture by saying, "You may be surprised to hear The United States has many serious Coke-bottle collectors, reportedly including our President. They have their own Vasari and E.H. Gombrich, rolled into one, in the person of Cecil Munsey, author of *The Illustrated Guide to the Collectibles of Coca-Cola.* And a "Hutchinson bottle", made before the present cap-top came into use, costs $ 200. You may find this even harder to believe, but many other Americans also collect early barbed wire. They support a barbed wire journal; and the main topics of *The Barbarian* are of course barbed-wire history and the market value of the rarer varieties. In short, however strange may be the collector's prizes, collecting itself can never stand alone".
By means of these frivolous examples, Joseph Alsop meant to introduce a serious topic: "Collecting can never stand alone. Every kind of collecting necessarily coexists with some sort of history of the thing collected and a collector's market". Alsop's examples, taken from various areas and at different times during the history of art, demonstrate his point. If this is true for Ruben's collection of antiques, for Rembrandt's collection of sea-shells, and for the plans for the great collections of the Uffizi Gallery conceived by the Grand Duke Leopoldo and the Abbot Lanzi, it is not less true for collections that have to do with completely new objects. If the Nüremberg Museum, well-known for its collection of German handicrafts produced during the Middle-Ages and the Renaissance, has today a modern section devoted to industrial products dating from the beginning of this century to the 1930's, it is thanks to the passionate research of art historian Tilmann Buddensieg, who has had the rigorous training of a medievalist. Dealing with fields not as familiar to us as painting or engraving, illuminated manuscripts, Renaissance bronzes or Meissen's china, the new collector has to draw a map of the objects constituting his collection by framing them within spatial and temporal coordinates, by establishing what comes first and what comes second, and by individuating in the temporal sequence either logical continuities or breaks due to events that are decisive, even if not intrinsically related to the developmental structures of the object collected.
In 1955, Helmut Gernsheim devoted a whole chapter at the end of his monumental *History of Photography* to the "necessity of a national museum and institute of photography". Gernsheim argued that there are various collections, both public and private, dealing with areas related to photography. However only a public collection with the purpose of preserving *interesting photographs* of the past and present for the future generations, would be able to save relics otherwise bound for dispersion or destruction, and furthermore would be able to constitute the frame for a history of photography.
A few years later, this desire, which had already been supported by *The Times* since 1952, was concretely realized in France, England, as well as in Germany although in a less centralized way. In Italy, as early as 1898, *Il Corriere della Sera* promoted the first initiatives for the establishment of a museum of photography. Since we still haven't emerged from that initial stage, and since what is being

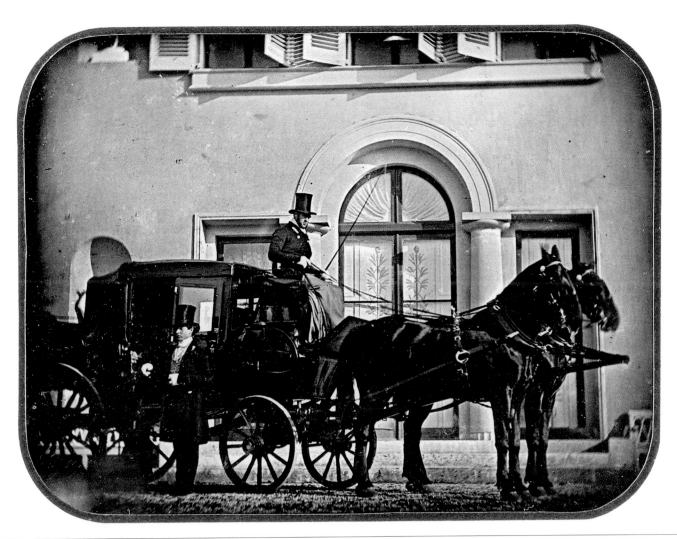

Jean-Gabriel Eynard-Lullin
Schweiz, 1775-1863

*Die Kutsche des Photographen
vor seinem Palais in Rolle*
1844
Daguerreotypie, 1/2 Platte

Jean-Gabriel Eynard-Lullin
Switzerland, 1775-1863

*The coach of the photographer
in Rolle*
1844
Daguerreotype, 1/2 plate

zu bewahren und überdies noch einen Rahmen für die Geschichte der Photographie herzustellen.

Einige Jahre später wurde dieser Gedanke, seit 1952 von der Zeitung *The Times* unterstützt, in Frankreich, England und obgleich weniger zentralisiert auch in Deutschland in die Tat umgesetzt. Schon 1898 förderte die Zeitung *Il Corriere della Sera* die ersten Initiativen für die Einrichtung eines Museums für Photographie in Italien. Da wir aus dieser ersten Phase immer noch nicht heraus sind und da die Entwicklungen im Bereich der Photographie sich immer noch auf die Bemühungen einiger privater Bürger beschränken, (trotz der guten Absichten einiger aufgeklärter Beamter) ist es wichtig, daß die Öffentlichkeit jetzt die Möglichkeit bekommt, eine große Sammlung wie die von Robert Lebeck zu sehen, die privat in systematischer Weise mit umfassendem Weitblick aufgebaut wurde, trotz finanzieller und zeitlicher Beschränkungen.

Die Chronologie am Anfang dieses Buches liefert wichtige Informationen, die die Sammlung nicht unmittelbar betreffen. In Form einer Zeittafel werden die wichtigsten Ereignisse in der Geschichte der Photographie dargestellt.

Wie man an dieser Sammlung erkennen kann, sind photographische Kreativität und technologische Innovation eng miteinander verbunden. Die Frage ist: Wie eng ist diese Verbindung? Es ist kein Zufall, daß Gottfried Semper, Verfechter der Theorie einer notwendigen Beziehung zwischen Material und architektonischem bzw. figurativem Ausdruck, und Alois Riegl, der die Wichtigkeit des Materials ablehnt und behauptet, die Kunstgeschichte sei eine notwendige formelle Entwicklung, beide Kinder des Zeitalters der Photographie sind. Wir sollten aber nicht vergessen, daß

Riegls Formalismus undenkbar wäre, gäbe es nicht die Photographie als Filter zwischen uns und den Objekten. In der Photographie scheinen die Objekte wirklich zu sein, obwohl sie zu reinen Vorstellungen umgewandelt sind. Die Abfolge einer kreativen Handlung – vorausgesetzt deren expressive Innovation entsteht nicht nur durch bewußte formelle Forschung, sondern auch im Zusammenspiel mit den zur Verfügung stehenden materiellen Mitteln – ist typisch für die Beziehung zwischen Kunst und industrieller Produktion, eine Beziehung, die die Photographie und Architektur miteinander gemein haben.

Die Architektur ist nicht verantwortlich für die Erfindung von Plexiglas oder von neuen Techniken Glas zu biegen oder Marmor und anderes Gestein in dünnen Schichten zu schneiden. Sobald die Industrie diese Innovationen den Architekten zur Verfügung stellte, nahmen diese sie sofort auf und wandelten sie in neue produktive Anforderungen um. Das gleiche gilt für die Photographie, und so gesehen kann man sagen, daß die Photographie tatsächlich ein Produkt ihrer Zeit ist. Die optischen und chemischen Eigenschaften vom Film, das Papier, auf dem die Photographie gedruckt wird, oder die chromatischen Qualitäten eines Farbdias erlauben uns, eine Photographie zu datieren, in ähnlicher Weise wie die Technologie ein modernes Gebäude unabhängig von dessen stilistischen Eigenschaften datierbar macht. Wird der Zeitraum zwischen Entwurf und Bau eines Projekts in Jahren gemessen, wie jetzt oft der Fall bei öffentlichen Gebäuden, sind es genau die technischen Details, die das tatsächliche Baujahr preisgeben werden. Auf dieser Grundlage wird klar, daß eine Geschichte der Photographie nicht lediglich eine Aufzählung von technischen

done in the field of photography is still due to the efforts of a few private citizens (in spite of the good intentions of some enlightened public officials), it is therefore important that the public now has the opportunity to see a large collection such as that of Robert Lebeck, which although a private one, has been put together in a systematic way and with a wide breadth of vision, despite limitations both financial and temporal.

The chronology at the beginning of this volume gives some essential information external to the collection and is presented in the form of a chronology describing the most significant events in the history of photography.

Photographic creativity and technological innovation are, as one can see from this collection, tightly linked. The problem which then presents itself is; to what degree? It is not by chance that Gottfried Semper, supporter of the theory of the necessary relationship between materials and architectural or figurative expression, and Alois Riegl, refuter of the importance of materials and assertor of a history of art as a necessary formal development, are both sons of the age of photography. We should not forget, however, that Riegl's formalism would be unthinkable if photography had not worked as a filter between us and the objects, presenting them to us as evidently real, yet transformed into pure images.

The steps which a creative activity takes – when its expressive innovations are produced not only by a consciously formal research, but also by the interaction with available material means – are those typical in a relationship between art and industrial production, a relationship which photography and architecture have in common.

New techniques of curving glass, systems for cutting marble and other stones into thin laminae, or plexiglass, were not invented by architects. However, as soon as these innovations were made available to them by industry, architects were immediately able to adopt them and to change them into new productive demands. The same process is true of photography, and seen from this angle it can be said that a photograph really is the product of its own time. The optical and chemical features of film, the paper on which a photograph is printed, or the chromatic qualities of a transparency, allow us to date a photograph much in the same way that technology makes a contemporary building datable independently from the project's stylistic features. When the period between project and construction can be measured in years, as often is the case with public buildings, it is precisely the technical detail which will reveal the true date of the building.

This said, it is evident that a history of photography cannot be just a comment on technical successes, or a lament over the disappearance of technical processes, abandoned due to cost, lack of market, production expediency, etc.

On the contrary, a history will have to look at the creative aspects involved in the relationship between available products and their imaginative exploitation by photography. The history of photography is then a history of the photographic imagination.

The Robert Lebeck collection has been put together with the purpose of documenting the most significant turning points in the tradition of photography, those in which the above mentioned relationship has been particulary intense. Photography, being bound to technical/industrial

Erfolgen ist oder eine Klage über das Verschwinden technischer Prozesse, die aus kosten- oder produktionsbedingten Gründen, mangelnder Nachfrage usw. aufgegeben wurden. Im Gegenteil, eine Geschichte muß die kreativen Aspekte berücksichtigen, die in der Beziehung zwischen den verfügbaren Produkten und deren phantasievoller Ausbeutung durch die Photographie eine Rolle spielen. Die Geschichte der Photographie wird damit zur Geschichte der photographischen Phantasie.

Die Sammlung Robert Lebeck wurde zum Zweck der Dokumentation der wichtigsten Wendepunkte in der Geschichte der Photographie bis zur Jahrhundertwende zusammengestellt, und zwar solcher Wendepunkte, bei der die oben beschriebenen Beziehungen besonders intensiv gewesen sind. Die Photographie, gebunden an technisch-industrielle Innovationen, kann nicht bloß als eine formale Entwicklung analysiert werden, wie dies bei anderen Kunstgeschichten möglich ist. Dies ist heutzutage leicht verständlich. Die moderne Photographie wird meist zu den Massenmedien gezählt. Ein berühmter Photograph braucht ein gut ausgestattetes Studio, kultivierte Öffentlichkeitsarbeit und eine solide Klientel. Die Käufer sind jetzt technisch besser vorbereitet und informiert als früher. Die Nachfrage nach Photographien für Werbung, Industrie, Journalismus oder Tourismus ist kaum zufällig oder unbefangen. Stattdessen beruht sie fast immer auf sorgfältiger Marktforschung, die zu sehr präzisen und berechneten Wünschen führt. Es scheint also, als wären Photographen heutzutage an Einschränkungen gebunden, die im voraus bestimmt werden. Trotzdem war zu Zeiten Nadars die perfekte Übereinstimmung zwischen dem, was ein Portraitphotograph

bieten und der Kunde verlangen konnte, eine Quelle künstlerischer Einschränkungen für den Photographen. Das Ergebnis hiervon war eine Art Bündnis zwischen Maler, Kunsthändler, Sammler und Photographen wie Nadar. Das gleiche passiert jetzt noch. Photographen, die die Autonomie ihrer Ausdrucksform bewahren wollen und sich oft einer Kunstgalerie oder anderen Kunstunternehmen anschließen. Die Geschichte der Photographie, so wie sie Anfang dieses Jahrhunderts in Europa und Amerika von Photographen und Sammlern, von Männern wie Alfred Stieglitz, konzipiert wurde, steckt voll von Beispielen für diese Reaktionsweise gegen das Ersticken des photographischen Berufs durch kommerzielle Zwänge.

Die Sammlung Robert Lebeck verfolgt das Ziel, dieser Geschichte wichtiges Material zu liefern. Die Photographien der Sammlung werden nicht als zusätzliche Dokumente geschriebener Geschichte, als anthropologische Dokumente oder als praktische Beispiele historischer Technik betrachtet. Im Gegenteil: die Sammlung dokumentiert eine Geschichte der Photographie, zeugt von der Arbeit der großen Meister und erlaubt die Erforschung der Möglichkeiten dieses Mediums. Wir erleben die Geburt der photographischen Rhetorik, deren Wortschatz sich schrittweise von dem der Malerei entfernt.

Das Verständnis für die Hauptinteressen der Pioniere der Photographie läßt erkennen, daß der Sammler selbst Photograph ist. Die Photographien sind nicht zufällig geordnet, sondern wurden wegen ihrer didaktischen und informativen Möglichkeiten sorgfältig ausgewählt, weil sie Teil einer Geschichte sind, die, wie immer, nicht nur einmal geschrieben werden kann.

innovations, cannot be analyzed in terms of mere formal development as can be done with other histories of art. This is easily understandable today. In fact, today's photography is almost always found within the mass-media industry. A renowned photographer needs a well-equipped studio, cultivated p.r., and a solid network of clients. Today's buyers are technically more prepared and well-informed than yesterday's. The demands for photographs to be used in advertising, industry, journalism or tourism are hardly ever random or ingenuous. Rather, they have almost always been carefully researched resulting in very specific and calculated requests. Thus it seems that today's photographers are bound by predetermined limitations. Nevertheless, in Nadar's time, the perfect correspondance between what the portrait photographer was able to offer, and what the customer was able to demand, was also a source of artistic bounderies for the photographer. This resulted in the forming of a sort of alliance between painters, art-dealers, collectors, and photographers such as Nadar. The same thing happens today. Photographers who want to perserve their expressive autonomy often associate themselves with an art gallery or some other artistic enterprise. The history of photography, such as was conceived in Europa and America at the beginning of this century by photographers and collectors as well as by men of culture, such as Alfred Stieglitz, is full of examples of this kind of reaction against the smothering of the photographic profession by commercial constraints. The Robert Lebeck collection aims at providing *that* very history with essential materials. The photographs in the collection are not seen as collateral documents of written history, as anthropological

documents or as practical demonstrations of a historical technique. On the contrary, the collection proposes a history of photography as both a testimony to the work of photography's great masters, and as a history which allows for the exploration of the medium's possibilites. In other words, we are witnessing the birth of photography's rhetoric, the vocabulary of which is little by little breaking away from that of painting.

The attention devoted to understanding the primary interests of the pioneers of photography reveals that the collector is a photographer himself. Upon seeing the collection, one is left with the impression that the photographs did not simply fall into place, but that they have been carefully selected for their didactic and informative potentialities, and for their being part of a history which, as usual, cannot be written only once.

9

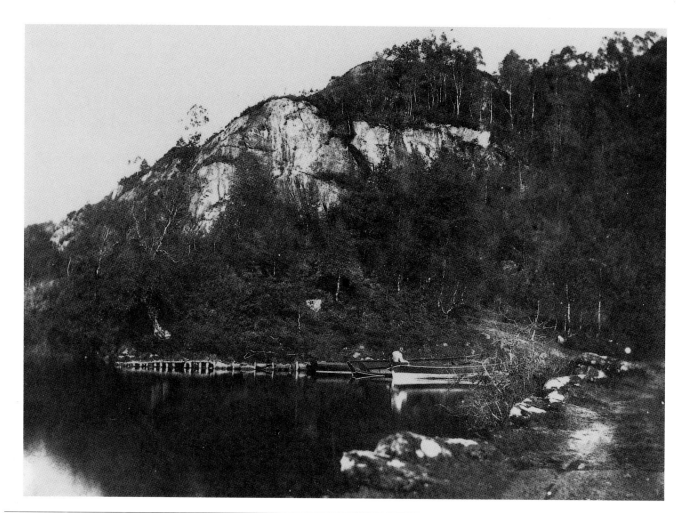

10 **William Henry Fox Talbot**
England, 1800-1877

Loch Katrine, Schottland
1844
Salzpapier-Abzug vom
Papier-Negativ
185 x 227 mm

William Henry Fox Talbot
England, 1800-187

Loch Katrine, Scotland
1844
Salt print from paper negative
185 x 227 mm

Die Sammlung Robert Lebeck
von Rainer Wick

Robert Lebeck wurde im März 1929 geboren. Sein Vater Kurt Lebeck erkrankte nach Abschluß seiner juristischen Examina im Jahr 1929 schwer; die Ehe wurde bald geschieden. Seine Mutter Maria Kühne lebte in Berlin und im Landhaus ihrer Familie in Jamlitz, wo Robert seine Schulferien bei den Großeltern verbrachte. Sein Großvater Walter Kühne malte und zeichnete und war begeisterter Sammler: Graphiken, Kunstzeitschriften, Bücher (seine Bibliothek umfaßte ca. 40.000 Bände), und zahlreiche Schränke bargen viele andere Geheimnisse, die er Robert zeigte.

1943, als Robert 15 Jahre alt war, wurde er als Soldat eingezogen und kam an die Front. Im Sommer 1945 wurde er aus amerikanischer Gefangenschaft entlassen und von Verwandten seines Vaters aufgenommen. Im Juli 1948 war das Abitur am Gymnasium in Donaueschingen geschafft. Der Weg war frei, Robert wollte nach Amerika auswandern. Von der Schweiz aus gelang ihm die Passage; nach einem Jahr Studium der Völkerkunde an der Universität Zürich erreichte der junge Mann die Neue Welt. Onkel Oscar, der Bruder seines Vaters, nahm ihn auf. Robert studierte an der Columbia Universität in New York Völkerkunde, jobte dazu als Tellerwäscher, Kellner, Lokomotiven-Wärter. Doch 1951 wollte Uncle Sam den Einwanderer Lebeck für den Korea-Krieg. Er ging zurück nach Europa und beschäftigte sich an der Universität Freiburg mit dem Hauptfach Geologie. Einige Monate später bewarb er sich bei der US-Armee in Heidelberg und bekam einen Job als Abteilungsleiter der Putzkolonnen.

1952 erhielt er seine erste Kamera, und am 15. Juli des gleichen Jahres druckte die *Rhein-Neckar-Zeitung* auf der Titelseite ein Photo Konrad Adenauers – Lebecks erstes Pressephoto war erschienen. Er verließ die US-Armee. Die Karriere des Photographen Robert Lebeck begann.

In den folgenden Jahren reiste Lebeck als Photojournalist für *Kristall* und *Stern* durch die ganze Welt, und die Kritik erklärte ihn zu „einem der besten Reportage-Photographen". Seit 1972 sammelt Robert Lebeck alte Photographie. Er entdeckte für sich die „Anfänger" und konzentrierte sich auf Photographien zwischen 1839 und 1870. Gegen Ende der 70er Jahre erweiterte sich der Horizont der Sammlung um dreißig Jahre bis zur Jahrhundertwende. Mit beeinflussend wurden die kunsthistorischen Kenntnisse und das Urteil in ästhetischen Fragen seiner dritten Ehefrau, der Hamburger Galeristin Elke Dröscher; sie heirateten 1978. Die Bilder der Sammlung Robert Lebeck vermitteln die Faszination, die vom neuen Medium ausging. Zwei Talente waren gefordert: künstlerisches und technisches Vermögen. Lebecks Pioniere der Kamera sind Künstler, überwiegend Maler mit guter technischer Hand oder Techniker mit künstlerischen Fingerspitzen. Robert Lebecks Sammlung ist nicht Enzyklopädie, sondern quasi impressionistische Geschichtsschreibung. Wo enzyklopädische Breite bald langweilt, vermittelt hier Auswahl viel begeisternder den Innovationswillen der Pioniere, ihre großartigen Leistungen und den hohen künstlerischen Wert früher Photographie.

The Robert Lebeck Collection
by Rainer Wick

Robert Lebeck was born in March of 1929. Maria Kühne, Robert's mother, lived at her family's country residence in Jamlitz, where Robert would spend his school holidays. Maria's father, Walter Kühne, who also lived at Jamlitz, was a collector of books (his library contained more than 40,000 volumes), graphics, and sketches. The old man had a special relationship with his first grandchild and during Robert's visits he would spend hours with the boy, showing him all the mysteries of his monumental collection of cultural artifacts.

In 1943, when Robert was 15 years old, he was sent to fight in the Second World War. He was taken prisoner by the Americans, who released him in the summer of 1945. During the following three years, he lived with of his father's relatives and graduated in 1948 from the Donaueschinger Gymnasium. Robert, then 20 years old, decided to leave Germany for America where his father's brother Oscar lived. Getting there was difficult, however, and Robert was obliged to stay in Switzerland for a year, where he studied ethnology at Zurich University before finally obtaining passage to The United States. Once in New York, Robert enrolled at Columbia University where he chose to major in anthropology, working part-time at odd jobs. In 1950 the Korean War broke out and a year later he was drafted by the American government. Unable to imagine fighting another war, Robert sailed for France. Once back in Europe, he went to Freiburg where he joined the University's geology department.

He then moved to Heidelberg where he found a job working for the U.S. Army. In 1952 Robert Lebeck acquired his first camera and on July 15th of the same year, *Rhein-Neckar-Zeitung* published on its front page a photograph taken by Lebeck of Konrad Adenauer, West Germany's first Chancellor. Lebeck promptly quit working for the U.S. Army and began his career as a photographer.

During the following years Lebeck travelled throughout the world taking photographs for the magazines *Kristall* and *Stern* establishing for himself a reputation as one of the best press-photographers in the world.

From his grandfather Lebeck inherited the passion of a collector, and in 1972 he began acquiring early photographs, dating mostly from the years between 1839 and 1870. Lebeck's aim was to understand the beginnings of photography through studying the images captured by the eyes of photography's pioneers.

Near the end of the 1970's, as Lebeck became more experienced as a collector and also more adept at raising funds for purchasing the photographs, he widened the scope of his collection to include prints from 1870 to the turn of the century. Lebeck married Elke Dröscher, a Hamburg gallery owner, who has helped Lebeck considerably in the formation of his collection.

The photographs of the Robert Lebeck Collection speak for themselves. They all reveal the excitement, initiative, and genius of artists giving birth to a new perspective on the image.

**Das erste Jahrhundert der Photographie:
Eine Chronologie**

„Es ist also kein Zweifel daran möglich, daß die erste Idee
der Photographie im Jahre 1793 gefaßt wurde!" schrieb
Nicéphore seinem Bruder Claude Niépce am 16. September
1824. Mit den ersten Versuchen der Gebrüder Niépce um
1798 beginnt die Zeittafel, die sich im wesentlichen auf
folgende Quellen beruft:

Helmut Gernsheim:
Geschichte der Photographie,
1983, Propyläen Verlag, Frankfurt a.M.

Wolfgang Baier:
Geschichte der Photographie,
1980, Schirmer/Mosel Verlag, München

Wolfgang Kemp:
Theorie der Photographie 1839-1912,
1980, Schirmer/Mosel Verlag, München (Bd. 1)

1798
Die Brüder Claude (1763-1828) und Nicéphore Niépce
(1765-1833) machen im italienischen Cagliari erste
Experimente, um die in der Camera obscura erzeugten
Bilder auf chemischen Wegen festzuhalten.

1802
In dem in London erscheinenden *Journal of the Royal
Institution* publiziert Thomas Wedgewood (1771-1805)
einen „Bericht über eine Methode, Glasbilder zu kopieren
und Silhouetten herzustellen durch Einwirkung von Licht
auf Silbernitrat".

1816
Nicéphore Niépce macht erste Papierphotographien mit
drei selbstgebauten Kameras aus dem Fenster seines
Arbeitszimmers in Saint-Loup-de-Varennes.

1819
Der englische Naturwissenschaftler John F.W. Herschel
(1792-1871) entdeckt die Eigenschaft des Natriumthiosulfats,
Silbersalze aufzulösen.

1822
Nicéphore Niépce gelingt mit Hilfe von Asphalt auf Glas die
erste lichtbeständige heliografische Kopie eines
Kupferstichs.

1826
Nicéphore Niépce erwirbt im Januar, nachdem er zehn
Jahre lang mit selbstgebauten Kameras gearbeitet hatte, in
Paris beim Optiker Vincent Chevalier seine erste
fachmännisch hergestellte Camera obscura. Durch
Chevalier lernt Niépce den Kunstmaler und Besitzer des
spektakulären Dioramas in Paris, Louis Jacques Mandé
Daguerre (1787-1851) kennen.

1827
Nicéphore Niépce belichtet acht Stunden den Blick aus
dem Fenster seines Arbeitszimmers auf einer mit Asphalt
lichtempfindlich gemachten Zinnplatte, 165 x 205 mm; die
erste erhalten gebliebene, lichtbeständige Photographie,
die früheste Aufnahme nach der Natur: ein Direktpositiv.

**The first century of photography:
A chronology**

"There can be not doubt that photography was first
conceived in the year 1793!" These lines were written by
Nicéphore Niépce in a letter to his brother on the
16th Sept. 1824. The following chronological table takes as
its starting point the experiments made by the Niépce
brothers in 1798. The following is a list of references, used
for this chronological table:

Helmut Gernsheim:
The History of Photography,
1969, McGraw-Hill, New York

Beaumont Newhall:
Latent Image,
1978 (Revised Edition), Heering-Edition, Seebruck

Wolfgang Kemp:
Theorie der Photographie,
1980, Schirmer/Mosel-Edition, Munich (Vol. I).

1798
The brothers Claude (1763-1828) and Nicéphore Niépce
(1765-1833) conduct in Cagliari (Italy) their first experiments
in trying to fix images, produced by the camera obscura,
using chemical means.

1802
Thomas Wedgewood (1771-1805) publishes in the London
Journal of the Royal Institution: "An account of a method of
copying painting upon glass and of making profiles by the
agency of light upon silver nitrate".

1816
From the window of his work-shop in Saint-Loup-de-
Varennes Nicéphore Niépce takes the first paper
photographs using three self-made cameras.

1819
The English natural scientist John F.W. Herschel (1792-1871)
discovers that natriumthio-sulphate is a solvent of silver salt.

1822
Nicéphore Niépce manages to produce the first light
insensitive heliographic copy of a copper engraving by using
asphalt on glass.

1826
In January Nicéphore Niépce, after working for 10 years
with his own self-made cameras, acquires his first
professionally built camera obscura from the Parisian optican
Vincent Chevalier. Through Chevalier he gets to know in
Paris the artist Louis-Jacques Mandé Daguerre (1787-1857),
who is in possession of the spectacular "Diorama".

1827
Nicéphore Niépce exposes the view from the window of his
workshop to a 165 x 205 mm tin-plate, made sensitive to
light by asphalt; this photograph still exists today, the first
light intensive photograph, the first photograph taken of
nature; a direct-positive.

1829
Nach fast dreijährigen Kontakten kommt es am
14. Dezember zu einem Gesellschafter-Vertrag zur
Verwertung der photographischen Erfindung zwischen
Niépce und Daguerre.

1834
Der englische Privatgelehrte William Henry Fox Talbot
(1800-1877) beginnt auf seinem Landsitz Lacock Abbey mit
photographischen Versuchen auf lichtempfindlichem
Papier.

1835
William Henry Fox Talbot photographiert das Fenster seiner
Bibliothek von innen: er stellt damit das erste Negativ her.
Mit seinen sehr kleinen Kameras, sogenannten
Mausefallen, gelingen ihm mehrere Negativ-Aufnahmen
seines Landsitzes. Trotz erster Erfolge setzt Talbot diese
Versuche nicht fort. Erst als Daguerres Verfahren 1839
publik wird, beeilt sich Talbot mit der Weiterentwicklung.
Daguerre entdeckt zu dieser Zeit das „latente Bild":
Belichtete Silberjodidplatten können mit Quecksilber-
dämpfen entwickelt werden. So gelingen praktikable
Belichtungszeiten.

1837
Daguerre findet nach langen Experimenten ein Fixiermittel:
Kochsalzlösung. Ein Stilleben dieses Jahres ist bis heute
erhalten.

1839
Paris, 7. Januar
François Arago (1786-1853), Physiker und Astronom, macht
in der Académie des Sciences, deren Sekretär er ist, kurze
Mitteilung über Daguerres Erfindung.

Paris, 20. Januar
Hippolyte Bayard (1801-1887) beginnt mit photo-
mechanischen Versuchen auf Papier.

London, 31. Januar
Die Royal Society ist Adressat einer Mitteilung William
Henry Fox Talbots über dessen photogenische Zeichnungen.

München, 9. März
Die Bayerische Akademie der Wissenschaften erhält
Kenntnis von Talbots Verfahren; die Professoren Carl August
von Steinheil (1801-1870) und Franz von Kobell (1803-1875)
beginnen umgehend mit photographischen Versuchen.

Paris, 20. März
Hippolyte Bayard erhält gute Ergebnisse im Direkt-Positiv-
Verfahren mit Papier.

New York, 20. Mai
Samuel F.B. Morse (1791-1872) teilt Daguerre dessen
Ernennung zum Ehrenmitglied der Academy of Design mit.

Paris, 24. Juni
Hippolyte Bayard zeigt 30 Fotografien öffentlich in einem
Auktionsraum.

1829
After almost three years of cooperation, on the
14th December, Niépce and Daguerre sign a contract,
outlining how they will exploit photography commercially.

1834
The English independent scholar William Henry Fox Talbot
(1800-1877) begins, on his country-estate of Lacock Abbey,
to experiment with light-sensitive paper.

1835
William Henry Fox Talbot produces a photograph of his
library window, taken from indoors. In so doing, he produces
the very first negative. Using his very small cameras
(so-called "mouse-traps") he manages to take several
negative photographs of his country-estate. Despite this
initial success Talbot does not carry on with these experi-
ments.
Only when Daguerre's process is published in 1839, does
Talbot speed up his own further research and development.
At this time Daguerre discovers the latent photograph –
exposed silver iodized plates developed by using mercury
vapour. Using this method it becomes possible to obtain
practical exposure times.

1837
After long experimentation Daguerre discovers a fixative:
sodium chloride solution.
Photography becomes practicable – a still-life taken in this
year has been preserved until today.

1839
Paris, 7th January
François Arago (1786-1853) a physicist and astronomer and
secretary of the French Academy of Science gives a brief
report about Daguerre's discovery;

Paris, 20th January
Hippolyte Bayard (1801-1887) begins his photochemical
experiments on paper;

London, 31st January
The "Royal Society" receives a report from William Henry
Fox Talbot on his photogenic drawings;

Munich, 9th March
The Bavarian Academy of Science takes notice of Talbot's
methods and Prof. Carl August von Steinheil (1801-1870)
and Prof. Franz von Kobell (1803-1875) immediately begin
their own experiments;

Paris 20th March
Hippolyte Bayard obtains favourable results with paper
using the direct-positive-process;

New York, 20th May
Samuel F.B. Morse (1791-1872) informs Daguerre of his
honorary membership of the Academy of Design;

Paris, 24th June
Hippolyte Bayard shows 30 photographs publicly in an
auction room;

Paris, 3. Juli
Die französische Regierung berät den Ankauf der Erfindung Daguerres.

Birmingham, August
William Henry Fox Talbot stellt 93 photogenische Zeichnungen aus.

London, 14. August
Daguerres Erfindung wird in England mit der Patent-Nummer 8194 geschützt.

Paris, 19. August
William Henry Fox Talbot schützt seine Erfindung mit einem französischen Patent.

Paris, 19. August
François Arago verkündet Einzelheiten und erläutert die Ergebnisse der Erfindung von Niépce und Daguerre auf einer gemeinsamen Sitzung der Académie des Sciences und der Académie des Beaux-Arts.

Paris, 3. September
Daguerre führt wöchentlich sein Verfahren dem Publikum vor.

Paris, 14. Oktober
Alfred Donné (1801-1878), Direktor des Charité, legt die erste Portraitaufnahme der Académie des Sciences vor.

Paris, Dezember
Thèodore Maurisset karikiert „die Daguerreotypomanie":

mit großer Eile findet die Daguerreotypie in aller Welt Interessierte.

1840
William Henry Fox Talbot entdeckt die Calotypie, die positive Salzpapierkopie vom Papiernegativ. Damit wird es möglich, beliebig viele Kopien herzustellen. Sein Negativ-Positiv-Prozeß erweist sich bald als zukunftsträchtigstes Verfahren der Photographie.

Im März eröffnet Alexander S. Wolcott (1804-1844) in den USA das erste Portrait-Atelier; zwölf Monate später,

1841
eröffnet Richard Beard (1801-1885), am 23. März das erste europäische Portrait-Atelier auf dem Dach des Polytechnikums in London.
Noël-Marie Paymal Lerebours (1807-1873) stellt im ersten kommerziellen Atelier Frankreichs im ersten Betriebsjahr bereits 1500 Portraits her.

1842
Hermann Biow (1810-1850) und Ferdinand Stelzner (1805-1894) dokumentieren den großen Brand in Hamburg (5. bis 8. Mai) und schaffen mithin die früheste photographische Reportage.

1843
In Edinburgh finden David Octavius Hill (1802-1870) und Robert Adamson (1821-1848) zusammen und schaffen in viereinhalb Jahren rund 1800 Calotypien.

Paris, 3rd July
The French government deliberates about the purchase of Daguerre's invention;

Birmingham, August
William Henry Fox Talbot exhibits 93 photogenic drawings;

London, 14th August
Daguerre's invention is protected in England, under patent-no. 8194;

14

Paris, 19th August
William Henry Fox Talbot protects his invention with a French patent;

Paris, 19th August
François Arago announces the details and results of Niépce and Daguerre's invention before a collective conference of the Academy of Science and the Academy of Fine Arts;

Paris, 3rd September
Daguerre presents his methods to a public audience once a week;

Paris, 14th October
Alfred Donné (1801-1878), director of the Charité presents the first photographic portrait to the Academy of Science;

Paris, December
Thèodore Maurisset draws a cartoon caricature entitled,

"Daguerreotype-Mania". With amazing speed, the world begins to show great interest in daguerreotypes.

1840
William Henry Fox Talbot discovers the calotype, the positive salt-paper copy from a paper-negative. It now becomes possible to reproduce as many copies as one chooses. His negative-positive process soon proves itself, as the method with the most future in photography.

In March Alexander S. Wolcott (1804-1844) opens the first portrait-studio in the USA. Twelve months later...

1841
On the roof of the London Polytechnic, Richard Beard (1801-1885) opens, on the 23rd March, the first European portrait studio.
Noël-Marie Paymal Lerebours (1807-1873) produces 1,500 portraits in his first year of business in the first commercial studio in France.

1842
Hermann Biow (1810-1850) and Ferdinand Stelzner (1805-1894) document the great fire of Hamburg (5th-8th May) and in so doing produce the first example of photographic journalism.

1843
In Edinburgh, David Octavius Hill (1802-1870) and Robert Adamson (1821-1848) begin a cooperation which in the 4 1/2 years they work together, produces 1,800 "calotypes".

1844
Talbots *The Pencil of Nature* erscheint ab 29. Juni. Es ist das erste Buch, in das Calotypien eingeklebt werden.
In Paris werden auf der Exposition des Produits de l'Industrie de France über 1000 Daguerreotypien gezeigt.

1847
Sir David Brewster (1781-1868) erfindet die zweiäugige Stereokamera.

1848
Abel Niépce de St. Victor (1805-1870) stellt Negative auf albuminisierten Glasplatten her. Er führt das nasse Kollodium-Verfahren ein.

1850
Louis Désiré Blanquart-Evrard (1802-1872) beschichtet Papier mit Albumin.

1851
Im März veröffentlicht Frederick Scott Archer (1813-1857) eine fundierte Beschreibung des nassen Kollodium-Verfahrens, das bis 1880 wichtigstes photographisches Verfahren bleiben wird.
Gustave Le Gray (1820-1862) verbessert die Transparenz des Papiernegativs durch ein Wachsbad, in das er das Photopapier vor der Sensibilisierung taucht.

1852
Der englische Photograph Roger Fenton (1819-1869), Mitglied des Londoner "Calotype Club", bereist mit seinen Kameras Kiew, St. Petersburg, Moskau und bringt erste Reisefotografien mit nach London.

1854
André Adolphe Eugène Disdéri (1819-1889) läßt am 27. November sein Patent auf Visitenkartenportraits eintragen.

1855
Roger Fenton reist erneut nach Rußland. Die erste Kriegs-reportage entsteht, 360 Aufnahmen illustrieren den Krim-Krieg. Im September publiziert der französische Chemiker J.M. Taupenot (1824-1856) sein trockenes Kollodium-Verfahren.

1858
Gaspard Félix Tournachon (1820-1910), genannt Nadar, macht aus einem Ballon erste Luftaufnahmen; am 23. Oktober läßt er sich die Idee patentieren, doch erst ab 1862 werden ihm gute Bilder gelingen.

1860
Nadar photographiert mit einer portablen Lichtanlage in den Pariser Katakomben und schenkt 100 gelungene Aufnahmen der Stadt Paris.

1861
Mathew B. Brady (1823-1896), Besitzer zweier großer Photoateliers in New York und Washington, rüstet eine Reihe von mobilen Photographen-Teams aus und läßt den amerikanischen Sezessionskrieg dokumentieren.

1844
Talbot's *The Pencil of Nature* is published on 29th June. It is the first book to contain "calotypes" stuck onto its pages.
In Paris 1,000 daguerreotypes are shown at the "Exposition des Produits de l'Industrie de France".

1847
Sir David Brewster (1781-1868) invents the binocular stereoscopic camera.

1848
Abel Niépce de St. Victor (1805-1870) produces a negative on a glassplate coated with albumen. He creates the so-called "wet collodion process".

1850
Louis Désiré Blanquart-Evrard (1802-1872) coats paper with albumen.

1851
In March Frederick Scott Archer (1813-1857) publishes a detailed paper on the "collodion-process", which is to remain the most important process until 1880. Gustave Le Gray (1820-1862) improves the transparency of the paper-negative by submerging it in wax before sensitizing the photographic paper.

1852
The English photographer Roger Fenton (1819-1869), a member of the London "Calotype Club" travels through Kiev, St. Petersburg and Moscow with his cameras, bringing back the first travel photographs to the English capital.

1854
André Adolphe Eugène Disdéri (1819-1889) patents on the 27th November his technique of producing carte-de-visite photographs.

1855
Roger Fenton travels again to Russia. This results in the first photographic documentation of war. 360 photographs illustrate the Crimean War. In September the French chemist J.M. Taupenot (1824-1856) publishes his dry-collodion process.

1858
Gaspard Félix Tournachon (1820-1910), known as Nadar, takes the first aerial photographs from an air balloon.
On the 23rd October he patents the idea even though he doesn't manage to take decent photographs until 1862.

1860
Nadar takes photographs in the Parisian Catacombes with the assistance of a portable, lighting set and presents 100 successful photographs to the city of Paris.

1861
Mathew B. Brady (1823-1896) the owner of two photographic studios in New York and Washington equips several mobile teams of photographers and documents the American Civil War.

1862
Der französische Pianist Louis Ducos du Hauron (1837-1920) publiziert Untersuchungen über farbphotographische Verfahrenstechniken.

1865
Nadar, Cameron, Rejlander, Talbot und andere stellen auf der Internationalen Photographie-Ausstellung in Berlin aus.

1868
Louis Ducos du Hauron präsentiert erste farbige Pigmentdrucke; er realisiert das erste Patent auf dem Gebiet der Farbphotographie.

1871
Die Kommunarden in Paris lassen sich bei den Barrikaden photographieren; aufgrund der Aufnahmen werden einige der Aufständischen identifiziert und strafverfolgt. Richard Leach Maddox (1816-1902) beschreibt seine Erfindung der Gelatinetrockenplatte; die Bromsilber-Gelatine-Trockenplatte findet umgehend Verbreitung.

1873
Hermann Wilhelm Vogel (1834-1898), Professor für Photochemie der Technischen Universität in Berlin, gibt im Dezember bekannt, daß ihm eine orthochromatische Sensibilisierung des Negativmaterials gelungen sei.

1877
Der Amerikaner Eadweard Muybridge (1830-1904) fertigt erste Reihenaufnahmen von sich bewegenden Motiven an.

1879
Johann Sachs in Berlin, Friedrich Wilde in Görlitz und Carl Haack in Wien erzeugen industriell Bromsilber-Gelatineplatten. Diese Trockenplatten ermöglichen Momentaufnahmen in Sekundenbruchteilen.
Karel Klič (1841-1926) entwickelt in Wien die Photogravure.

1880
Stephen H. Horgan veröffentlicht im New Yorker *Daily Graphic* ein gerastertes Halbtonphoto; erst drei Jahre später wird der Münchener Georg Meisenbach (1841-1912) in der Leipziger *Illustrierte Zeitung* Gleiches tun.

1888
„Kodak Nr. 1", die erste Rollfilmkamera, kommt auf den Markt. Der Apparat wiegt 680 Gramm, ist sehr preiswert und enthält ein „Stripping"-Filmband für immerhin 100 Bilder.
Jacob A. Riis (1849-1914) liefert sozialdokumentarische Photographien: Er photographiert Mißstände in New Yorks Armenviertel, Manhattans Lower East Side. Theodore Roosevelt reagiert beim Anblick der Photographen betroffen und ergreift konkrete Maßnahmen, um die Übel zu beseitigen.

1889
Peter Henry Emerson (1856-1936) propagiert mit seinem Buch *Naturalistic Photography* ein antiromantisches Glaubensbekenntnis der naturalistischen Photographie.

16

1862
The French pianist Louis Ducos de Hauron (1837-1920) publishes experiments with coloured photographic techniques.

1865
Nadar, Cameron, Rejlander, Talbot and others display their work at "Internationale Photographie-Ausstellung", Berlin.

1868
Louis Ducos de Hauron presents the first colour pigmented prints and is first to obtain a patent in the field of colour photography.

1871
The Communards allow themselves to be photographed at the barricades in Paris; as a result, several of the rebels are identified and punished.
Richard Leach Maddox (1816-1902) publishes his invention of the so-called Gelatine-dry-plate-process. The Bromsilver-gelatine-dry-plate becomes widely used.

1873
Hermann Wilhelm Vogel (1834-1898), Professor of photochemistry at the Technical University of Berlin, announces in December that he has successfully managed to sensitise the negative using an orthochromatic process.

1877
The American Eadweard Muybridge (1830-1904) completes the first series of photographs of a moving object.

1879
Johann Sachs (Berlin), Friedrich Wilde (Görlitz) and Carl Haack (Vienna) manufacture an industrial bromsilver-gelatine-plate.
These dry-plates make it possible to take split second exposures.
Karel Klič (1841-1926) develops the photo-gravure in Vienna.

1880
Stephen H. Horgan publishes in New York *Daily Graphic* a half-tone photograph, using the silk-screen process. Not until three years later does Georg Meisenbach (1841-1912) from Munich do the same thing in the Leipziger *Illustrierte Zeitung*.

1888
"Kodak No. 1", the first filmroll-camera is brought onto the market. It weighs 680 grams, is very inexpensive and comes with a so-called "Stripping" for no less than 100 photographs.
Jacob A. Riis (1849-1914) is the first to take photographs with sociological impact: he photographs the squallor in New York's poorer quarters of Manhattan's Lower East Side. Roosevelt is touched by these photographs and takes concrete measures to alleviate the misery.

1889
Peter Henry Emerson (1859-1936) propagates in his anti-romantic book *Naturalistic Photography,* the doctrine of naturalistic photography.

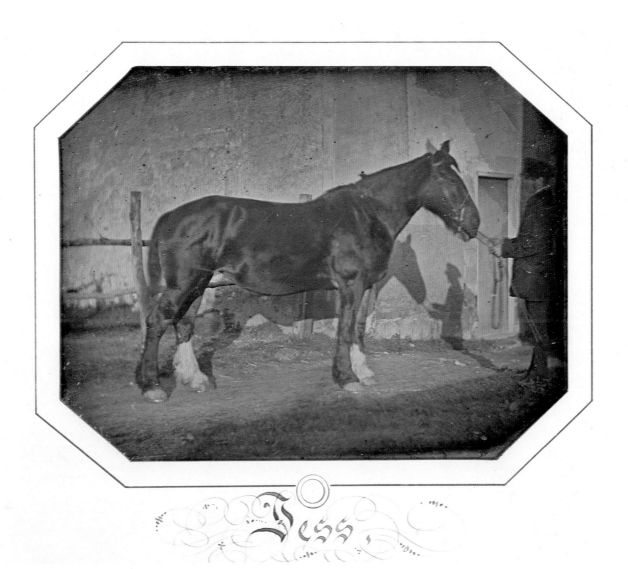

Louis-Auguste Bisson
Frankreich, 1814-1876

Das Pferd „Jess"
Ca. 1841
Daguerreotypie, 1/4 Platte

Ein auf dem Passepartout geprägtes Monogramm mit den Initialen „B.A." kann mit „Bisson Aîné" (Bisson der Ältere) übersetzt werden. Diese Photographie ist vermutlich die früheste Aufnahme eines Tieres. Auf ihrer Rückseite klebt eine handgeschriebene Etikette: „Daguerreotypé par Bisson, 65 rue St. Germain- L'Auxerrois à Paris". Die später als „Bisson Frères" berühmten Photographen benutzten dann gedruckte Etiketten.

Louis-Auguste Bisson
France, 1814-1876

The Horse "Jess"
1841 ca.
Daguerreotypie, 1/4 plate

A monogram bearing the initials "B.A." embossed on the passepartout most likely refers to "Bisson Aîné" (Bisson the Elder). This photograph is probably the first ever of an animal. On the back there is a hand written etiquette; "Daguerreotypé par Bisson, 65 rue St. Germain-L'Auxerrois à Paris". The brothers were later known as the "Bisson Frères" and used printed etiquettes.

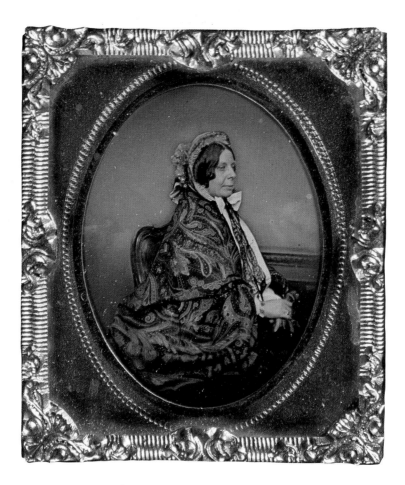

William Edward Kilburn
England

Portrait einer Dame
Ca. 1850
Kolorierte Miniatur-
Daguerreotypie

Mit drei mal vier Zentimetern
gehört dieses Portrait zu den
seltenen erhalten gebliebenen
Beispielen von Miniatur-
Daguerreotypien. Ihr Kolorist
muß mit einem Vergrößerungs-
glas gearbeitet haben, um eine
derartige Detailtreue zu errei-
chen.

William Edward Kilburn
England

Portrait of a Lady
1850 ca.
Coloured miniature
daguerreotype

Measuring three by four
centimeters, this portrait
represents a rare example
of miniature photography.
The colourist must have worked
with the assistance of a
magnifying glass to achieve this
degree of accuracy.

William Edward Kilburn
England

Junge mit Hut und Stock
Ca. 1855
Kolorierte
Stereo-Daguerreotypie

Mit der Erfindung der Photographie sahen viele Miniaturen-Maler ihren Lebensunterhalt gefährdet. Einige von ihnen fanden Arbeit, indem sie Daguerreotypien kolorierten. M. Mansion war einer der erfolgreichsten Umsteiger; ihm werden diese Arbeiten auf Kilburns Daguerreotypien zugeschrieben.

William Edward Kilburn
England

Boy with Top Hat and Stick
1855 ca.
Coloured stereo-daguerreotype

The livelihoods of many miniature painters were lost with the advent of daguerreotypes. Some of them were able, however, to find work by skillfully colouring daguerreotypes. M. Mansion was one of the most successful of these converts, and is thought to be responsible for the work done on Kilburn's daguerreotypes.

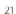

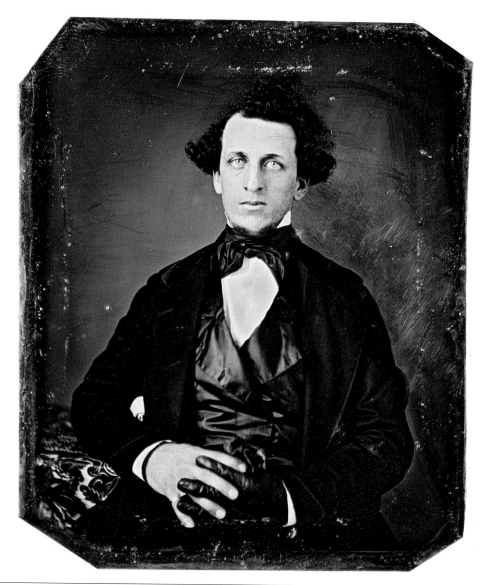

22 **Anonym**
Vereinigte Staaten von Amerika

Der Mann mit dem schwarzen Handschuh
Ca. 1855
Kolorierte Daguerreotypie,
1/6 Platte

Während in Europa Daguerreotypien manuell poliert wurden, benutzten amerikanische Daguerreotypisten dazu Maschinen, was zu einer gleichmäßigeren Oberfläche, zu stärkerem Glanz und — wie dieses Bildbeispiel gut zeigt — zu einer intensiveren Schärfe führte.

Anonymous
United States

The Man with the Black Glove
1855 ca.
Coloured daguerreotype,
1/6 plate

Whereas daguerreotypes were polished by hand in Europe, the American daguerreotypes were polished by machines. This led to a higher gloss, a more even finish, and increased sharpness, characteristics of this daguerreotype, which was probably taken in The United States.

23

Anonym

Drei Portraits des selben Herrn
Ca. 1850
Kolorierte Daguerreotypie,
1/6 Platte

Portraits dieser Art wurden
meist drei- oder viermal
aufgenommen, worauf die
best-gelungene Aufnahme
herausgeschnitten und in
einem Schmuckstück gerahmt
wurde. Vermutlich galten im
vorliegenden Fall alle drei
Aufnahmen als gelungen,
weshalb diese Platte unge-
schnitten erhalten blieb.

Anonymous

*Three Portraits of the Same
Man*
1850 ca.
Coloured daguerreotype,
1/6 plate

More often than not a
daguerreotype of this kind is
taken three or four times so that
the best portrait can be chosen
and cut out to become an
ornament. It is thought that in
this case, because all three
portraits turned out well, the
plate was left intact.

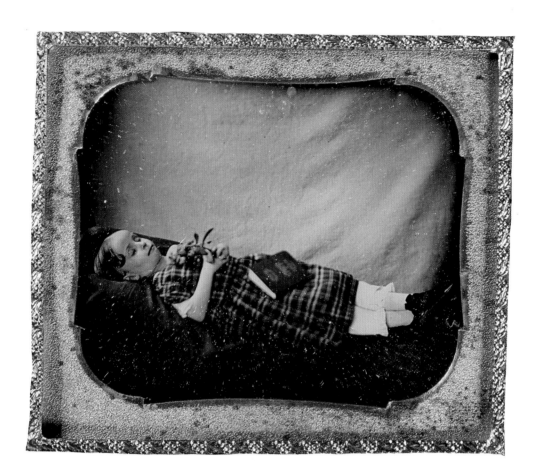

24

Anonym
England

*Totes Kind mit Blumen in der
Hand*
Ca. 1850
Daguerreotypie, 1/9 Platte

Anonymous
England

*Dead Child with Flowers in her
Hands*
1850 ca.
Daguerreotype, 1/9 plate

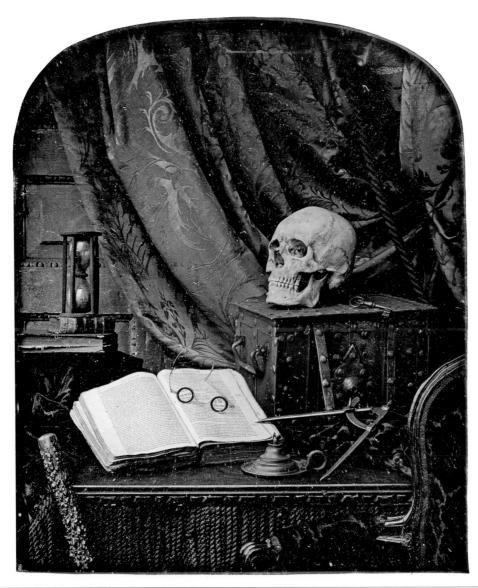

T.R. Williams
England, 1825-1871

„Memento Mori"
Ca. 1853
Stereo-Daguerreotypie

T.R. Williams, ein berühmter
Einzelgänger, zählt zu den
rätselhaftesten, interessantesten
Pionieren der Photographie.
„Memento Mori" ist eine
Komposition klassischer
Symbole der viktorianischen
Literatur, Dichtung und Kunst.

T.R. Williams
England, 1825-1871

"Memento Mori"
1853 ca.
Stereo-daguerreotype

T.R. Williams, a noted recluse,
was one of the finest, yet most
enigmatic of the early
photographers. "Memento
Mori" is a composition of
symbols common to the
literature, poetry and art of
Victorian England.

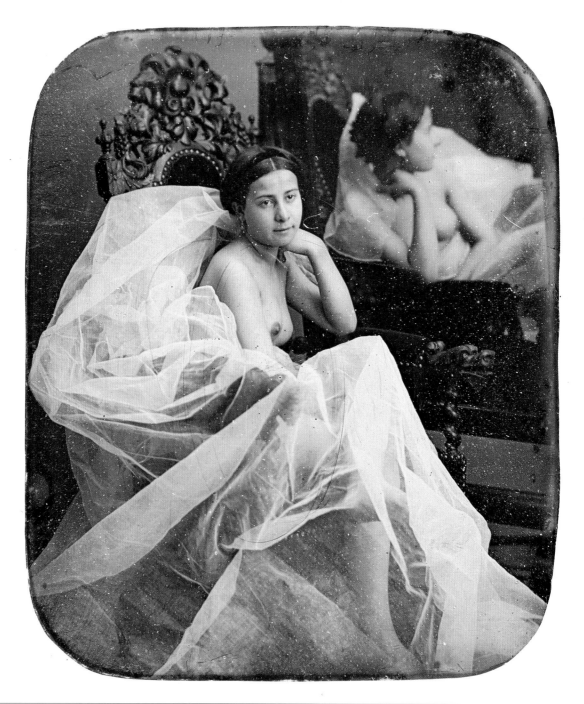

Firma Andres Krüss
Deutschland, 1791-1848

Weiblicher Akt mit Spiegel
Ca. 1855
Stereo-Daguerreotypie

Andres Krüss arbeitete als Optiker und Mechaniker in Hamburg. Als er an der Cholera gestorben war, übernahmen seine Frau und seine beiden Söhne Edmund Johann und William Andres partnerschaftlich seine Firma, die sich in der Folge auch mit der Photographie beschäftigte.
Die Identifikation dieser

Daguerreotypie gelang mit der Hilfe des reich ornamentierten Sessels, in dem das Modell sitzt: Edmund Krüss verwandte dasselbe Requisit für ein Selbstportrait, welches nun Bestandteil der Sammlung des Museums für Kunst und Gewerbe in Hamburg ist.

Andres Krüss Company
Germany, 1791-1848

Female Nude with Mirror
1855 ca.
Stereo-daguerreotype

Andres Krüss worked as an optician and mechanic in Hamburg. When he died of cholera, his wife and two sons Edmund Johann and William Andres went into partnership and carried on the business, expanding to include photography. The identification of this daguerreotype was made possible due to the large

ornamental armchair in which the model is sitting. Edmund Krüss used the same prop for his self-portrait, which is part of the collection of the Museum für Kunst und Gewerbe in Hamburg.

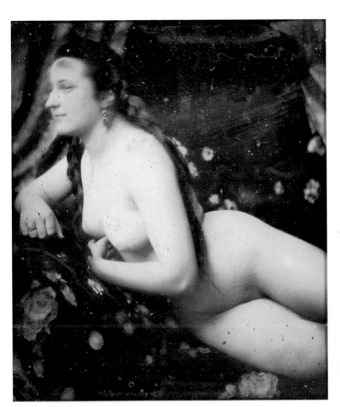

Anonym

Akt mit Zöpfen
Ca. 1855
Kolorierte
Stereo-Daguerreotypie

Weder die Requisiten wie
Mobiliar oder Schmuck, noch
der sichtbare Hintergrund des
Ateliers, in dem diese
Aufnahme entstand, machen
eine zweifelsfreie Identifizierung
des Autoren möglich. Weil die
meisten Akt-Daguerreotypien
anonym in Paris entstanden,
dürfte auch diese französischer
Provenienz sein.

Anonymous

Nude with Braids
1855 ca.
Coloured stereo-daguerreotype

Neither the props – in this case
the furniture and jewelry –
nor the background of the
studio help to identify this
daguerreotype accurately.
It is probably of french origin.

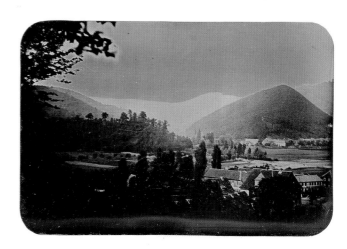

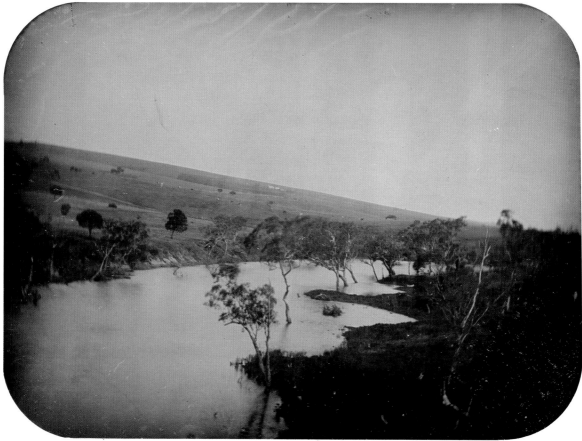

Anonym

Überflutender Fluß in Victoria, Australien
1855
Daguerreotypie, 1/4 Platte

Dr. Eduard Biewend
Deutschland, 1814-1888

Harz-Landschaft bei Königshütte
27. Juni 1854
Daguerreotypie, 1/2 Platte

Nebst Landschaften photographierte der Hamburger Amateurphotograph Dr. Eduard Biewend vielfach seine Frau und seine Kinder. Unglücklicherweise wurden vor nicht sehr langer Zeit über einhundert seiner Aufnahmen zerstört, weil sie „bloß Landschaftsaufnahmen" waren.

Anonymous

Flooded River Landscape in Victoria, Australia
1855
Daguerreotype, 1/4 plate

Dr. Eduard Biewend
Germany, 1814-1888

Harz Mountain Landscape, near Königshütte
June 27, 1854
Daguerreotype, 1/2 plate

Besides photographing landscapes, Biewend, a resident of Hamburg and a dedicated amateur, also took many photographs of his wife and children. Unfortunately, over one hundred of his daguerreotypes were destroyed because they concerned themselves "only with landscapes".

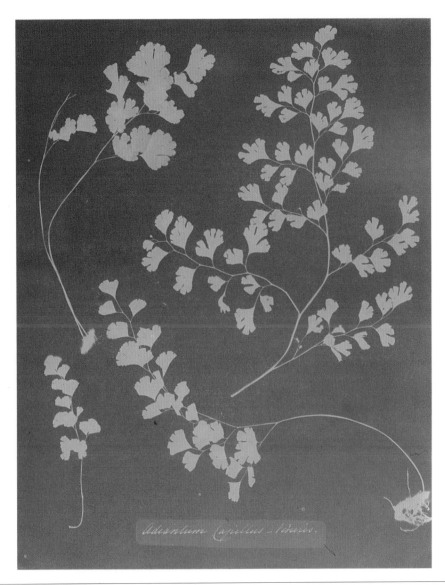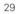

Anna Atkins
England, 1799-1871

„Adiantum Capillus Veneris"
1854
Zyanotypie
255 x 220 mm

Diese Zyanoptypie ist Teil des 1854 erschienenen Albums *Cyanotypes of British and Foreign Flowering Plants and Ferns.* Die Zyanotypie repräsentiert eines der frühesten photographischen Verfahren und Anna Atkins ist vermutlich die erste Frau, die photographierte.

Anna Atkins
England, 1799-1871

"Adiantum Capillus Veneris"
1854
Cyanotype
255 x 220 mm

This cyanotype or blue print is part of the album *Cyanotypes of British and Foreign Flowering Plants and Ferns,* published in 1854. Cyanotype was one of the first photographic processes and Anna Atkins was possibly the first woman photographer.

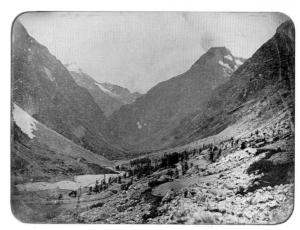

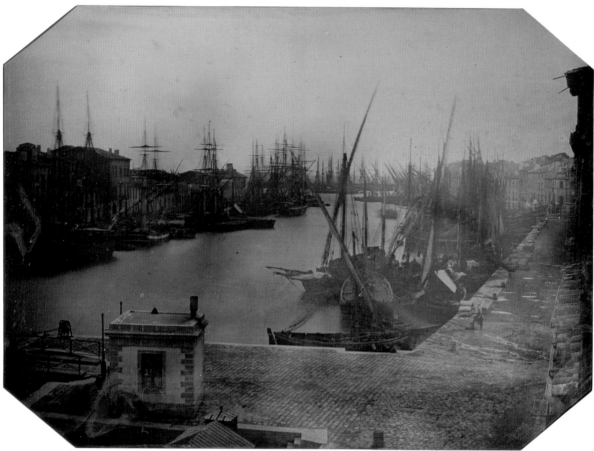

30 **François Adolphe Certes**
Frankreich, 1805-1887

Der Hafen von Sète in Südfrankreich
Ca. 1845
Daguerreotypie, 1/1 Platte

Der Direktor für Wasser- und Forstwirtschaft im Distrikt Sète gilt als einer der besten Amateurphotographen der Frühzeit. Diese Aufnahme ist nicht von Hand koloriert: Eine massive Überbelichtung des Himmels führte zur Solarisation und läßt den Himmel blau erscheinen.

François Adolphe Certes
Frankreich, 1805-1887

Baumgrenze in den Französischen Alpen
Ca. 1845
Daguerreotypie, 1/1 Platte

Diese Daguerreotypie, in der Nähe von Grenoble aufgenommen, ist vermutlich die früheste im Gebirge entstandene Aufnahme.

François Adolphe Certes
France, 1805-1887

The Port of Sète in the South of France
1845 ca.
Daguerreotype, 1/1 plate

Administrative director of Water Supply and Forestry in the district of Sète, François Adolphe Certes ranks among the best amateur photographers of the "early period". This daguerreotype has not been coloured by hand. The massive over-exposure of the sky led to solarization causing the sky to turn blue.

François Adolphe Certes
France, 1805-1887

Tree line in the French Alps
1845 ca.
Daguerreotype, 1/1 plate

This daguerreotype was taken near Grenoble, and is thought to be the first photograph taken in a mountain range.

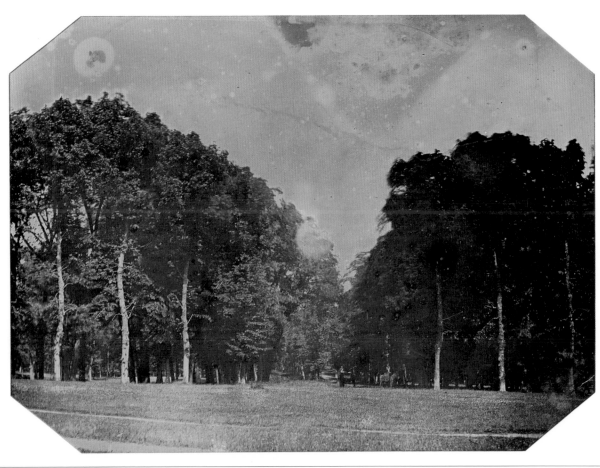

François Adolphe Certes
Frankreich, 1805-1887

Wald und Wiese
Ca. 1845
Daguerreotypie, 1/1 Platte

Das Mädchen auf dem Maultier ist Certes' Tochter; die Person links der Tochter ist vermutlich Certes' Frau, diejenige rechts dürfte ein Diener der Familie sein.

François Adolphe Certes
France, 1805-1887

Forest and Meadow
1845 ca.
Daguerreotype, 1/1 plate

The girl sitting on the mule is Certes' daughter. The two other people in the photograph are believed to be his wife (on the left) and a servant (on the right).

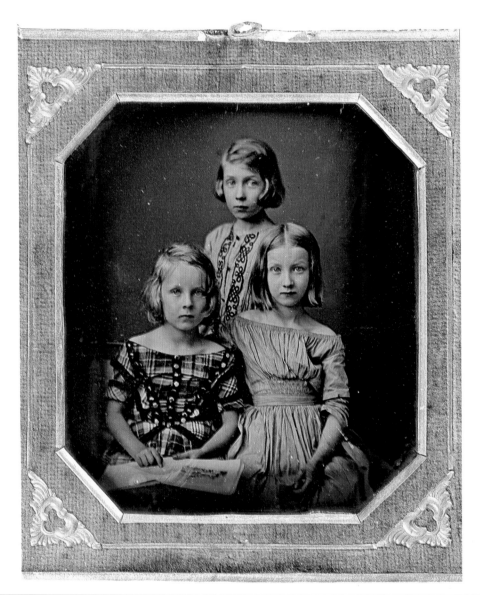

32 **Gustav Oehme**
Deutschland, 1817-1881

Portrait dreier Mädchen, Berlin
Ca. 1845
Daguerreotypie, 1/6 Platte

Gustav Oehme, ein Optiker und Mechaniker, erlernte die Photographie bei Louis Jaques Mandé Daguerre in Paris, wo 1840 seine ersten Aufnahmen gelangen. 1843 richtete er in Berlin in der Jägerstraße 20 sein Atelier ein. Diese Daguerreotypie liegt unter einem achteckigen Passepartout aus Samt in einem Lederetui.

Gustav Oehme
Germany, 1817-1881

Portrait of Three Girls, Berlin
1845 ca.
Daguerreotype, 1/6 plate

Gustav Oehme, an optician and mechanic, studied photography under Louis Jacques Mandé Daguerre in Paris where, in 1840 his first daguerreotypes were taken. In 1843, he set up his own studio in 20 Jägerstrasse, Berlin. This daguerreotype is mounted on an octagonal velvet passepartout and is cased in leather.

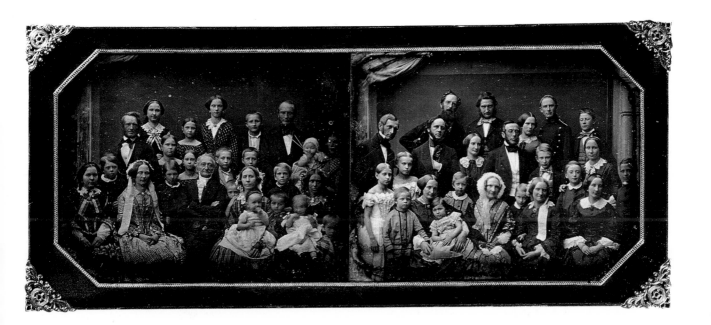

Johann Eberhard Feilner
Deutschland, 1802-1869

*Die Feier der Goldenen
Hochzeit der Familie Magnus,
Bremen*
Ca. 1845
Daguerreotypie,
zwei 1/2 Platten

Johann Eberhard Feilner
Germany, 1802-1869

*The Golden Wedding
Anniversary of the Magnus
Family, Bremen*
1845 ca.
Daguerreotype, two 1/2 plates

34 **Gustav Oehme**
Deutschland, 1817-1881

*Gruppenportrait in Oehmes
Atelier in Berlin*
11. April 1847
Daguerreotypie, 1/6 Platte

Gustav Oehme
Germany, 1817-1881

*Group Portrait in Oehme's
Studio Berlin*
April 11, 1847
Daguerreotype, 1/6 plate

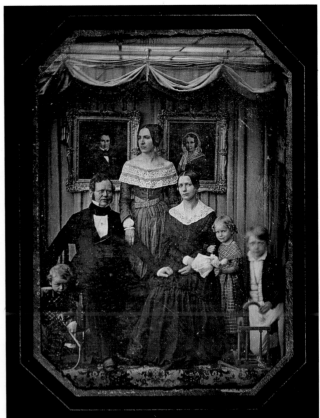

Anonym
England

Die Familie Seymour:
Mutter und fünf Kinder
Ca. 1853
Kolorierte Daguerreotypie,
1/1 Platte

Ein außerordentliches Beispiel
einer Daguerreotypie: Die
technische und kompositorische
Brillianz dieser Aufnahme der
Familie des Gold- und Silber-
händlers William Seymour
(12, Upper St. Martin Lane)
demonstriert den technischen
Fortschritt des Mediums.

Johann Eberhard Feilner
Deutschland, 1802-1869

Familienportrait vor
Portraitgemälden, Bremen
Ca. 1845
Daguerreotypie, 1/2 Platte

Anonymous
England

The Seymour Family:
Mother and Five Children
1853 ca.
Coloured daguerreotype,
1/1 plate

An outstanding example
of a daguerreotype; the
technical and compositional
brillance of this photograph,
talken of the London gold and
silver merchant William
Seymour's family, (12, Upper St.
Martin Lane), demonstrates
the progress of the medium.

Johann Eberhard Feilner
Germany, 1802-1869

Family with Painted Portraits,
Bremen
1845 ca.
Daguerreotype, 1/2 plate

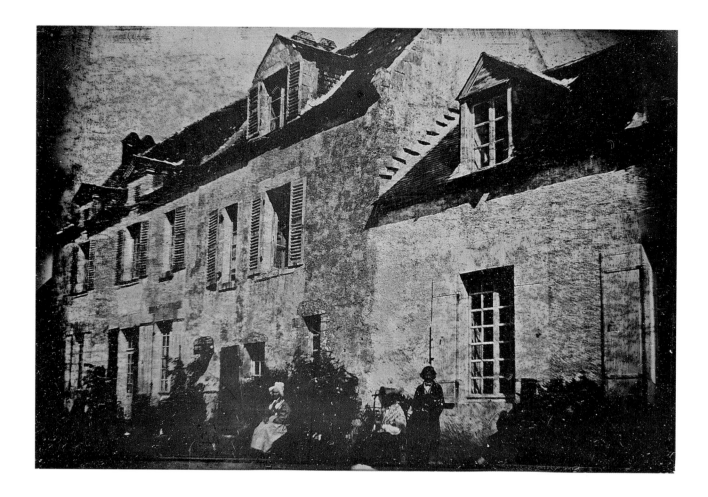

36 **Vincent Chevalier**
Frankreich, 1770-1840

„La Bernardière"
Ca. 1839
Daguerreotypie, 1/2 Platte

Vincent Chevalier machte
Daguerre und Niépce
miteinander bekannt und war
einer der ersten, der mit
Daguerre zusammenarbeitete.
Optiker von Beruf, widmete
sich Chevalier nahezu
ausschließlich der Entwicklung
photographischer Optik. Bevor
er 1840 starb, hatte er sein
Atelier am Quai de l'Horloge

Nr. 69 in Paris seinem Schüler
A. Richebourg übergeben. „La
Bernardière" ist die früheste
noch existierende Aufnahme
einer Gruppe von Menschen.

Vincent Chevalier
France, 1770-1840

"La Bernardière"
1839 ca.
Daguerreotype, 1/2 plate

Vincent Chevalier introduced
Daguerre to Niépce and was
one of the first to work with
Daguerre. Optician by trade,
Chevalier devoted himself
almost entirely to the
development of photographic
optics. Before his death in 1840,
Chevalier gave his studio at 69
Quai de l'Horloge in Paris to his
student and follower A.

Richebourg. "La Bernardière"
is the earliest photograph still
in existence in which people are
included.

Baron Louis-Adolphe
Humbert de Molard
Frankreich, 1800-1874

Lagny sur Marne, nahe Paris
1846
Daguerreotypie, 1/2 Platte

Fasziniert von der Chemie und chemischen Experimenten fand Humbert de Molard früh zur Photographie. Ab 1843 schuf er ausgezeichnete Daguerreotypien, und vor 1846 gelang ihm die Entwicklung eines eigenen Verfahrens zur Herstellung von Papierphotographien, ohne Kenntnis und

Hilfe der publizierten Ergebnisse auf diesem Gebiet.

Baron Louis-Adolphe
Humbert de Molard
France, 1800-1874

Lagny on the Marne, near Paris
1846
Daguerreotype, 1/2 plate

A fascination with chemical conjuring, and the skilled manipulation of materials, led Humbert de Molard to photography early on. By 1843, he was an accomplished daguerreotypist and before 1846 he had evolved paper processes without the published experiences of others to aid him.

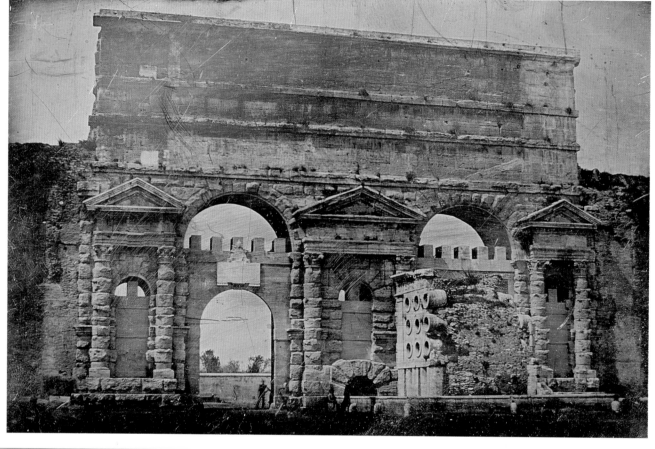

Anonym

Porta Maggiore in Rom
Ca. 1846
Daguerreotypie, 1/2 Platte

Die Porta Maggiore, 52 vor
Christus im Auftrag des Claudius
erbaut, war nicht nur einer der
Haupteingänge zur Stadt, sie
war auch Stütze zweier der
wichtigsten Aquädukte der
Stadt, der Aqua Claudia und der
Aqua Anio Novus. Nahe des
Tores befindet sich das
berühmte, 1838 entdeckte
Grab des Marcus Virgilius

Eurysaces, das die Form eines
Backofens hat.

Anonymous

Porta Maggiore in Rome
1846 ca.
Daguerreotype, 1/2 plate

The Porta Maggiore, erected by
Claudius in 52 B.C., was not
only one of the most important
entrances into the city, but
acted as a support for two of
Rome's main aquaducts,
the Aqua Claudia and the Aqua
Anio Novus.
Adjacent to the gateway is the
famous tomb of Marcus
Virgilius Eurysaces which has

the form of a baker's oven.
The tomb was discovered
in 1838.

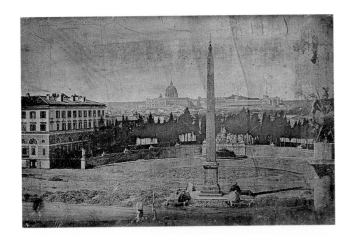

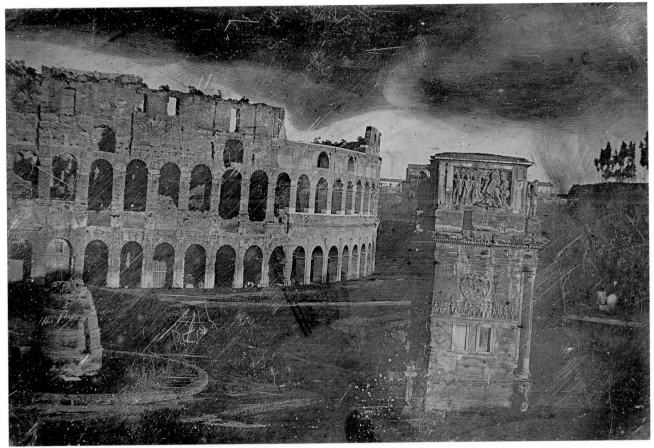

Anonym

Piazza del Popolo in Rom
Ca. 1846
Daguerreotypie, 1/2 Platte

Der ägyptische Obelisk im
Zentrum der Piazza del Popolo,
Kaiser Augustus hatte ihn von
Heliopolis nach Rom bringen
lassen, wurde erst 1589
aufgerichtet. 1823 fügte der
Architekt Giuseppe Valadier
die Brunnen mit den vier
wasserspeienden Löwen hinzu.
Zur Zeit dieser Aufnahme
wurde der Platz gepflastert.

Vierzig Jahre später beschrieb
August Hare diese Sicht gen
Westen auf St. Peter als
interessanteste Aussicht der
Welt... „ruiniert durch die
Einrichtung einiger mit
scheußlichen Stukkaturen
versehenen Bauwerke im
schlimmsten Chicagoer Stil".

Anonymous

Das Kolosseum in Rom
Ca. 1846
Daguerreotypie, 1/2 Platte

Rund ein Jahr vor dem
Entstehen dieser Aufnahme
waren die Restaurierungs-
arbeiten am Kolosseum
beendet worden.

Anonymous

Piazza del Popolo in Rome
1846 ca.
Daguerreotype, 1/2 plate

The Egyptian obelisk in the
centre of the Piazza del Popolo,
brought to Rome from
Heliopolis by Emperor
Augustus, was not erected until
1589. In 1823, architect
Giuseppe Valadier added the
basins with their four water-
sporting lions.
At the time this photograph was
taken, the square was in the

process of being paved. Forty
years later, August Hare
described the view westwards,
with the tower of St. Peter's in
the distance, as "the most
interesting view in the world...
spoilt by the erection of a
succession of hideous stuccoed
buildings in the worst style
of Chicago".

Anonymous

Colosseum in Rome
1846 ca.
Daguerreotype, 1/2 plate

Restoration work on the
Colosseum ended a year before
this photograph was taken.

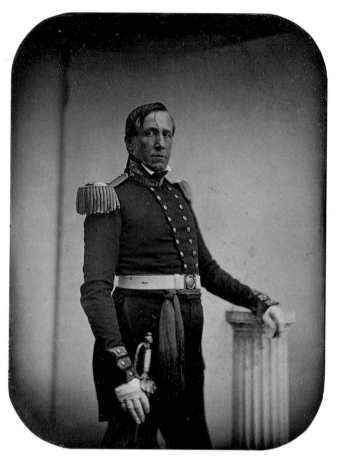

Southworth & Hawes
Vereinigte Staaten von Amerika

*„US-General John E. Wool"
(1784-1869), Boston*
Ca. 1850
Daguerreotypie, 1/1 Platte

Albert Sands Southworth
(1811-1894), in Vermont
geboren, begann 1840 zu
photographieren. Durch
seinen Freund J. Pennell machte
er die Bekanntschaft mit
Samuel B. Morse, der bei
Daguerre dessen Verfahren
erlernt hatte. Southworth und
Pennell gründeten 1840 in
Boston ein Atelier. Drei Jahre

darauf übernahm Josiah J.
Hawes (1808-1901) Pennells
Anteil und das Atelier wurde
unter der Firma „Southworth
& Hawes" sehr erfolgreich bis
1862 weitergeführt.

Anonym

Contessa Bonacossi, Florenz
Ca. 1845
Daguerreotypie, 1/6 Platte

Southworth & Hawes
United States

*"US-General John E. Wool"
(1784-1869), Boston*
1850 ca.
Daguerreotype, 1/1 plate

Born in Vermont, Albert Sands,
Southworth (1811-1894) began
producing daguerreotypes in
1840. Through his friend,
J. Pennell, he met Samuel
Morse, who had studied under
L.J.M. Daguerre. In 1840,
Southworth and Pennell set up
a daguerreotype studio in
Boston. Three years later,
Josiah J. Hawes (1808-1901)

took Pennell's place and
they continued the firm as
"Southworth & Hawes".
They ceased doing business
in 1862.

Anonymous

Contessa Bonacossi, Florence
1845 ca.
Daguerreotype, 1/6 plate

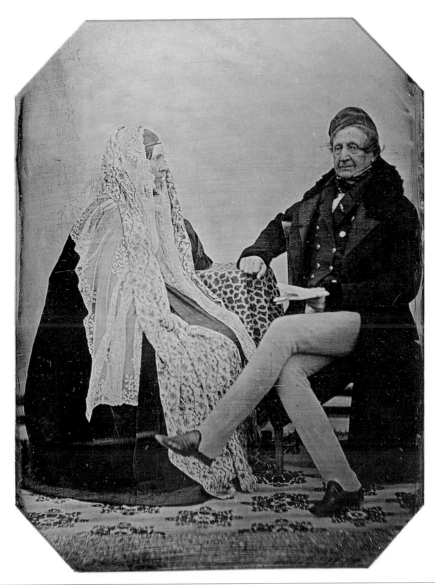

Jean-Gabriel Eynard-Lullin
Schweiz, 1775-1863

*Selbstportrait mit Ehefrau
in Genf*
Ca. 1843
Daguerreotypie, 1/2 Platte

Der Genfer Bankier, Finanz-
berater und Diplomat Eynard-
Lullin begann im Alter von
fünfundsechzig Jahren zu
photographieren. Seine
Sammlung von rund einhundert
Daguerreotypien gehört zum
Schönsten, was Amateur-
Photographen in der Frühzeit
geleistet haben.

Jean-Gabriel Eynard-Lullin
Switzerland, 1775-1863

*Self-portrait with his Wife,
Geneva*
1843 ca.
Daguerreotype, 1/2 plate

The Geneva banker, financial
adviser and diplomat Eynard-
Lullin decided to take up
photography at the age of sixty-
five. His collection of
approximately one-hundred
daguerreotypes contains some
of the earliest and finest
amateur photographs of
domestic scenes in existence.

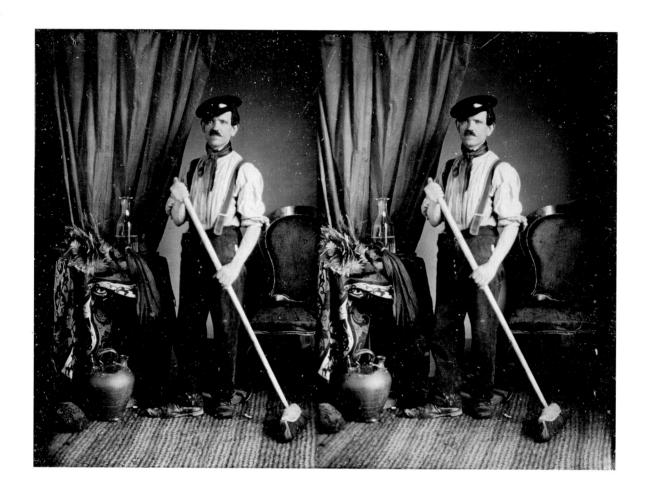

42 **Anonym**

Straßenkehrer
Ca. 1860
Kolorierte Stereo-
Daguerreotypie, 1/2 Platte

Die Draperie und insbesondere
der links des Straßenkehrers
am Boden stehende Wasserkrug
lassen vermuten, daß diese
Aufnahme in Spanien entstand.

Anonymous

Sweeper
1860 ca.
Coloured stereo-daguerreotype,
1/2 plate

The ornamental drapery and the
water pitcher standing on the
floor to the left of the sweeper
suggest a Spanish origin.

Anonym
Deutschland

Schlüsselübergabe
Ca. 1855
Daguerreotypie, 1/4 Platte

Diese Aufnahme zeigt
Rudolf Ferdinand Klotz bei der
Übergabe des Schlüssels eines
Salzdepots.

Anonymous
Germany

Handing over the Key
1855 ca.
Daguerreotype, 1/4 plate

This daguerreotype shows
Rudolf Ferdinand Klotz handing
over the key to the salt depot.

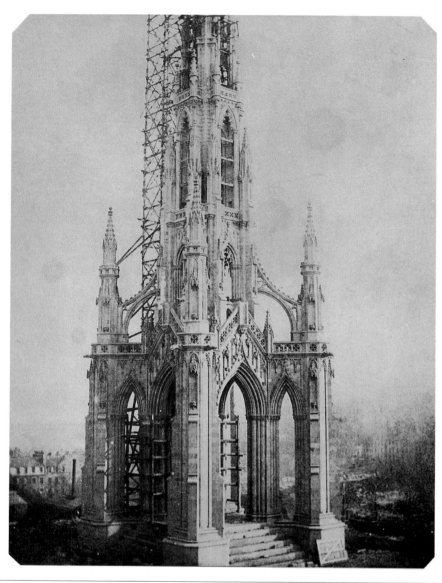

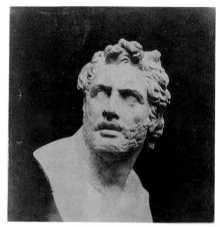

44

William Henry Fox Talbot
England, 1800-1877

*Sir Walter Scott's Monument,
Edinburg*
1844
Salzpapier-Abzug vom
Papier-Negativ
230 x 185 mm

Die abgebildete Kalotypie ist die
zweite aus der dreiundzwanzig
Bilder umfassenden Serie
Sun Pictures in Scotland. Die
Abbildung zeigt das Bauwerk
kurz vor dessen Fertigstellung
im Jahre 1844.

William Henry Fox Talbot
England, 1800-1877

Die Büste des Patrokles
1840
Salzpapier-Abzug vom
Papier-Negativ
225 x 185 mm

William Henry Fox Talbot war nicht
nur Erfinder des negativ/positiv-
Prozesses – er gab auch das
erste mit Photographien illu-
strierte Buch heraus. 1834 hatte
er mit Experimenten begonnen,
Bilder der Natur auf Papier
dauerhaft festzuhalten. Um
1835 gelang ihm die Erfindung
eines zwar mangelhaften aber
tauglichen Prozesses, genannt

William Henry Fox Talbot
England, 1800-1877

*Sir Walter Scott's Monument,
Edinburgh*
1844
Salt print from paper negative
230 x 185 mm

This photograph is the second
of the twenty-three images
which comprise the series *Sun
Pictures in Scotland*. It shows
the monument just before it
was completed in 1844.

William Henry Fox Talbot
England, 1800-1877

Bust of Patroclus
1840
Salt print from paper negative
225 x 185 mm

William Henry Fox Talbot not
only invented the negative/
positive process, but he also
produced the first books
illustrated with photographs. In
1834, he began experimenting
with ways for, "natural images
to imprint themselves durably
and remain fixed upon paper".
By 1835, he had devised his
imperfect but workable

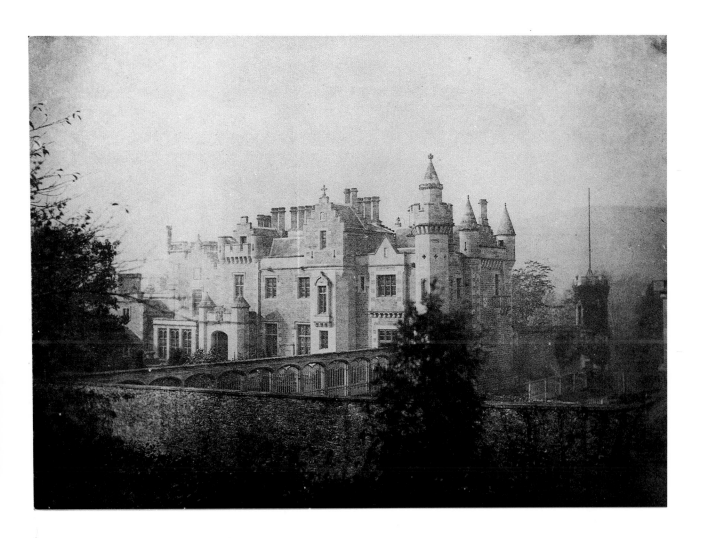

"photogenische Zeichnung", und ihm gelang die Herstellung von Papiernegativen, von denen er Positive ziehen konnte. Talbots erste Aufnahmen waren Photogramme: lichtsensitives Papier wurde – unter Blättern, Spitzen und anderen Objekten abgedeckt – dem Licht ausgesetzt. Er fixierte auch einige Bilder, die er mit einer sehr kleinen camera obscura aufnahm; es seien „Aufnahmen, von denen man annehmen könne, sie seien das Werk von liliputaner Künstlern". Seine anderen vielfältigen Interessen hinderten ihn an einer Weiterentwicklung der Verfahren bis 1839, als er – da Daguerres Erfindung publik wurde – Prioritätsansprüche anmeldete. 1840 gelang ihm die Entwicklung des wesentlich verbesserten negativ/positiv-Verfahrens: der Kalotypie, auch Talbotypie genannt. Talbot photographierte sein bevorzugtes Objekt, die Büste des Patrokles im Jahre 1840 achtmal. Er benutzte die Marmorbüste als Modell, um Portrait-Beleuchtungen auszuprobieren.

William Henry Fox Talbot
England, 1800-1877

Abbotsford Castle, Schottland
1844
Salzpapier-Abzug vom
Papier-Negativ
185 x 230 mm

photogenetic-drawing process and had produced paper negatives from which paper positives could be printed. Talbot's first images were photograms – light sensitive paper darkened by exposure beneath leaves, lace or other objects. He also recorded some very small camera obscura images, describing them „as might be supposed to be the work of some Lilliputian artist". Other interests caused him to put his work aside until 1839, when, hearing of L.J.M. Daguerre's invention of the daguerreotype, he immediately put in a claim for the priority of his own process. In 1840, Talbot worked out an improved version – the calotype (also called the talbotype). In 1840, Talbot photographed his favourite subject, the bust of Patroclus, eight times. Thus, he learned that static subjects with interestingly variable surfaces such as sculpture, made excellent subjects for his photographic experiments.

William Henry Fox Talbot
England, 1800-1877

Abbotsford Castle, Scotland
1844
Salt print from paper negative
185 x 230 mm

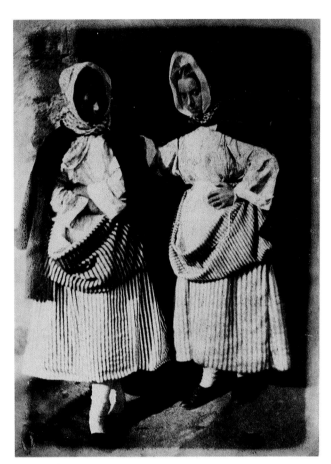

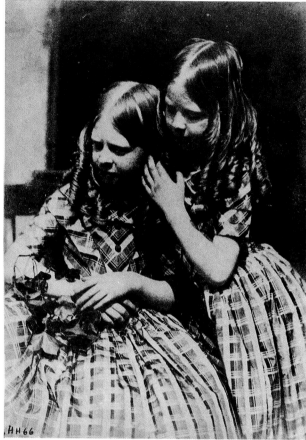

Hill & Adamson
Schottland

„Fishwives", New Haven
Ca. 1846
Salzpapier-Abzug vom
Papier-Negativ
195 x 145 mm

David Octavius Hill (1802-1870) war ein in Edinburg wohl-bekannter Maler, der sich auf Anraten Sir David Brewsters für die Photographie zu interessieren begann, um sie als Gedächtnisstütze zu nutzen. Robert Adamson (1821-1848) hatte in Edinburg ein Photo-graphie-Atelier eröffnet. 1843 fanden die beiden zusammen

und schufen in den viereinhalb Jahren ihrer Zusammenarbeit rund 1.800 Kalotypien, die zum Schönsten gehören, was die Photographie zu bieten hat. Der Tod des gerade 27jährigen Adamson setzte der Arbeit ein Ende.

Hill & Adamson
Schottland

„Misses Grierson"
Ca. 1845
Salzpapier-Abzug vom
Papier-Negativ
200 x 142 mm

Hill & Adamson
Scotland

"Fishwives", New Haven
1846 ca.
Salt print from paper negative
195 x 145 mm

„The bulky and distincitive dress of the fishwives, its solid folds emphasized by the stripes, gave them a sculptural dignity remarked on by Dr. John Brown who reviewed the calotypes in 1846... The shallow focal plane of the calotypes and the strongly cast shadows, emphasized the resemblance to classical bas-reliefs, especially

in this kind of composition with its feeling of processional movement". (Sara Stevenson)

Hill & Adamson
Scotland

"Misses Grierson"
1845 ca.
Salt print from paper negative
200 x 142 mm

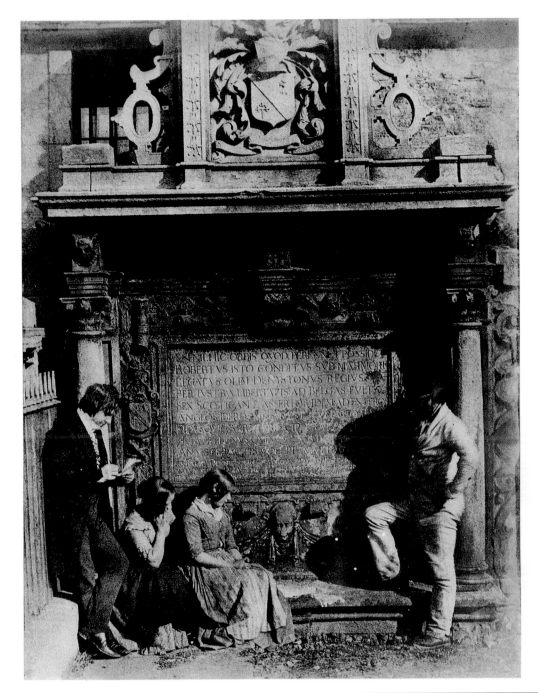

Hill & Adamson
Schottland

Greyfriars Friedhof, Edinburg
Ca. 1845
Salzpapier-Abzug vom
Papier-Negativ
200 x 150 mm

Eine Reihe der Kalotypien von
Hill & Adamson wurde im
Greyfriars Friedhof auf-
genommen. Liegt es an der
Morbidität des Viktorianismus
oder an der obsessiven
Beziehung zum Tod in einer
Gesellschaft, in der der Tod
allgegenwärtig, die Mortalitäts-
raten enorm hoch waren?
Unabhängig von vermutbaren

Motiven der Photographen
stand der Greyfriars Friedhof
mit seinen Grabmalen vor-
wiegend aus dem 17. Jahr-
hundert als einer der
pittoresken, interessantesten
Orte der Stadt zur Wahl.
Der Stehende auf der linken
Seite der Abbildung ist David
Octavius Hill.

Hill & Adamson
Scotland

*Greyfriars Churchyard,
Edinburgh*
1845 ca.
Salt print from paper negative
200 x 150 mm

Some of the calotypes taken by
Hill & Adamson were taken in
Greyfriars' Churchyard. This
perhaps can be explained by
the prevalent Victorian
"morbidity", or an obsession
with death, only natural in a
century when the mortality rate
was abnormally high and death
was common place.
Nevertheless, Greyfriars'

Churchyard, with its particularly
decorative 17th Century tombs,
is one of the most picturesque
sites in Edinburgh. The man on
the left side: David Octavius
Hill.

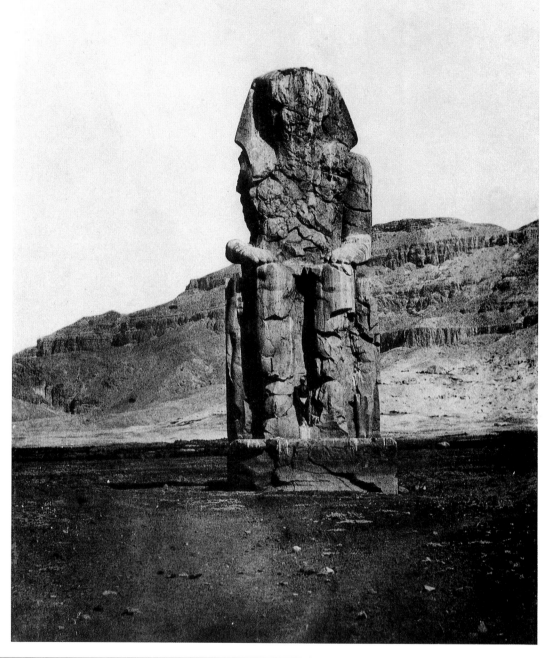

Maxime Du Camp
Frankreich, 1822-1894

Memnonskoloss in Theben
1850
Salzpapier-Abzug von
Blanquart-Evrard (Lille) vom
Papier-Negativ
197 x 157 mm

Maxime Du Camp, ein Journalist aus Paris, erlernte das Photographieren von Gustave Le Gray. Zwischen 1849 und 1851 bereiste er mit Gustave Flaubert im Auftrag der französischen Regierung Ägypten und den Nahen Osten, um Bauwerke und Monumente zu dokumentieren. Die Reisen führten zur Publikation des Buches *Egypte,*

Nubie, Palestine et Syrie, dem ersten wesentlichen französischen Buch, in dem Photographien enthalten waren. Dieses Album kostete 500 Goldfranken und war enorm erfolgreich. Die abgebildete Aufnahme isoliert den südlich stehenden der beiden Monolithen, denjenigen mit fehlendem rechten Arm. Um

die Größe des Werkes zu illustrieren, bat Du Camp einen aus seiner Reisegruppe, den Matrosen Hadiji Ismael, sich zwischen die Beine des Kolosses zu stellen.

Maxime Du Camp
France, 1822-1894

Monolithic Colossus in Thebes
1850
Salt print by Blanquart-Evrard
(Lille) from paper negative
197 x 157 mm

Maxime Du Camp, a journalist in Paris, learned photography from Gustave Le Gray. Between 1849 and 1851, commissioned by the French government, he and Gustave Flaubert travelled extensively in Egypt and the Near East, photographing monuments for documentary purposes. This trip resulted in the publication of the book

Egypte, Nubie, Palestine et Syrie, the first major French book in which original photographs were included. The album cost 500 gold francs and was a huge success. The "Southern Colossus", with missing right arm, has been photographed alone, isolated from its companion statue. In order to illustrate the size of the

Colossus, Du Camp had one of his party, the sailor Hadiji Ismael, stand between the statue's legs.

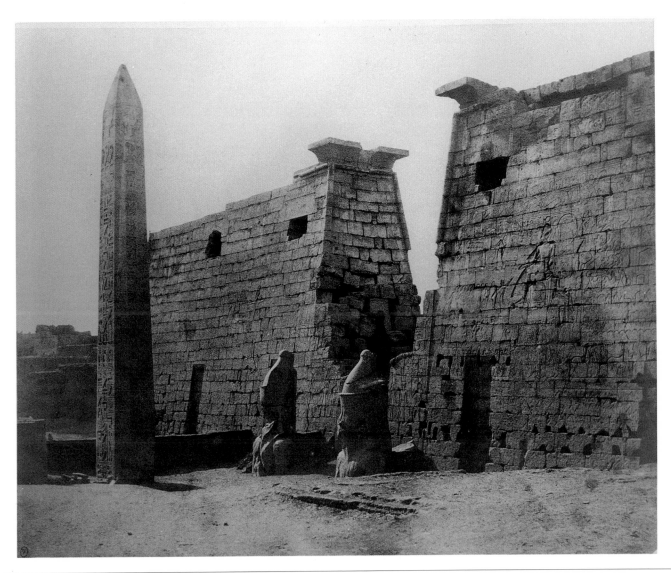

Félix Teynard
Frankreich, 1817-1892

*Der Obelisk des Tempels von
Luxor, Ägypten*
1851/1852
Salzpapier-Abzug von
H. de Fonteny (Paris) vom
Papier-Negativ
250 x 305 mm

Félix Teynard, ein Ingenieur,
bereiste Ägypten in den Jahren
1851 und 1852. Er brachte rund
160 Kalotypien nach Paris, mit
denen der Verleger Goupil ein
Buch produzierte, welches —
obwohl es fast 1000 Goldfranken
kostete — ein sehr interessiertes
Publikum fand und bald zur
Rarität wurde.

Félix Teynard
France, 1817-1892

*The Obelisk at the Temple
of Luxor, Egypt*
1851/1852
Salt print by H. de Fonteny
(Paris) from paper negative
250 x 305 mm

Félix Teynard was an engineer
who travelled and photographed
in Egypt between 1851 and
1852. The trip yielded approxi-
mately 160 calotypes which
were made available to a very
interested readership by the
Parisian publisher Goupil.
Even in its own time, the book
was to become a rarity as it cost
almost 1000 gold francs.

(Photographié par Charles Hugo.)

S'ils ne sont plus qu'mille, Eh bien, j'en sais ! si même
ils ne sont plus qu'cent, je brave encor Sylla;
S'il en demeure dix, je serai le dixième;
Et s'il n'en reste qu'un, je serai celui-là.

Victor Hugo
Jersey 2 décembre 1852

50 **Charles Hugo**
Frankreich, 1826-1871

Portrait von Victor Hugo, Jersey
1853
Salzpapier-Abzug vom
Papier-Negativ
102 x 72 mm

1851 begleiteten Charles und
François-Victor ihren Vater
Victor Hugo ins Exil auf die
Kanalinsel Jersey.
Victor Hugo zeigte vehementes
Interesse an der Photographie.
Viele Aufnahmen entstanden
in seiner Regie, vermutlich auch
dieses Portrait, das Teil eines
Familien-Albums war. Der
Aufnahme fügte Hugo ein

Gedicht bei, welches er mit
dem 2. Dezember 1853 datierte
und signierte:

S'ils ne sont plus que mille eh
bien, je ne sais! Si même ils
ne sont que cent, je brave
encore Sylla
S'il en demeure dix, je serai le
dixième; Et s'il n'en reste qu'un,
je serai celui-là.
Victor Hugo
Jersey 2 décembre 1853

Charles Hugo
France, 1826-1871

Portrait of Victor Hugo, Jersey
1853
Salt print from paper negative
102 x 72 mm

In 1851, Charles and François-
Victor accompanied their father
Victor Hugo in exile to the
Channel Island Jersey. Victor
Hugo showed an animated
interest in photography and
directed many photographs
himself; presumably, this
portrait was no exception.
It is part of a family album and is
attached to one of his poems,

signed and dated December,
1853:

S'ils ne sont plus que mille eh
bien, je ne sais! Si même ils ne
sont que cent, je brave encore
Sylla
S'il en demeure dix, je serai le
dixième; Et s'il n'en reste qu'un,
je serai celui-là.
Victor Hugo
Jersey 2 décembre 1853

Victor Hugo
Frankreich, 1802-1885

„Grosnez Castle", Jersey
17. Juni 1853
Salzpapier-Abzug vom
Papier-Negativ
118 x 94 mm

Victor Hugo
France, 1802-1885

"Grosnez Castle", Jersey
June 17, 1853
Salt print from paper negative
118 x 94 mm

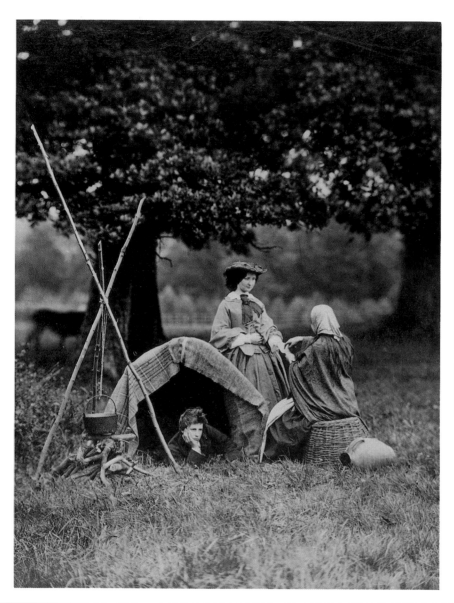

John Dillwyn Llewelyn
England, 1810-1882

„The Gypsy Party"
Ca. 1853
Albuminpapier-Abzug vom
nassen Kollodium-Glas-Negativ
196 x 148 mm

John Dillwyn Llewelyn, Sohn
des englischen Parlamentariers
Lewis Weston Dillwyn, photo-
graphierte hauptsächlich die
Landschaften in der Umgebung
seiner Heimat Penllergare in
Süd-Wales. Er war mit einer
Cousine Talbots, mit Emma
Talbot verheiratet. Zeit seines
Lebens blieb Llewelyn Amateur-
Photograph, dem die Freude an

der Photographie wichtiger war
als ihre kommerzielle Nutzung.
Die Aufnahme zeigt die Kinder
Llewelyns beim „Zigeuner-
spielen" im Park von Penllergare.

John Dillwyn Llewelyn
England, 1810-1882

"The Upper Fall",
Penllergare, Wales
1853
Albuminpapier-Abzug vom
nassen Kollodium-Glas-Negativ
280 x 240 mm

John Dillwyn Llewelyn
England, 1810-1882

"The Gypsy Party"
1853 ca.
Albumen print from
wet-collodion glass negative
196 x 148 mm

John Dillwyn Llewelyn, son of the
English Member of Parliament
Lewis Weston Dillwyn, photo-
graphed mainly the countryside
near his home in Penllergare,
South Wales. Llewelyn, who was
married to Emma Talbot, a cousin
of William Henri Fox Talbot,
remained an amateur, taking
photographs for pleasure rather
than for profit.

The picture shows the children
of Llewelyn playing gypsies
in the parc of Penllergare.

John Dillwyn Llewelyn
England, 1810-1882

"The Upper Fall",
Penllergare, Wales
1853
Albumen print from
wet-collodion glass negative
280 x 240 mm

John Dillwyn Llewelyn
England, 1810-1882

„Penllergare Woods", Wales
Ca. 1856
Albuminpapier-Abzug vom
nassen Kollodium-Glas-Negativ
293 x 235 mm

André Giroux
Frankreich, 1801-1879

Französische Landschaft
Ca. 1855
Salzpapier-Abzug vom
retuschierten Kollodium-Glas-
Negativ
265 x 325 mm

Der Maler André Giroux war
Sohn jenes Alphonse Giroux,
der Daguerres Ausrüstung
herstellte. Auch da, wo er
exzessiv retuschierte,
entstanden meist
hervorragende Arbeiten.

John Dillwyn Llewelyn
England, 1810-1882

"Penllergare Woods", Wales
1856 ca.
Albumen print from
wet-collodion glass negative
293 x 235 mm

André Giroux
France, 1801-1879

French Landscape
1855 ca.
Salt print from retouched
collodion glass negative
265 x 325 mm

André Giroux, a painter, was the
son of Alphonse Giroux, maker
of Daguerre's equipment.
Most of his pictures, even with
their excessive retouching,
are exceptional photographs.

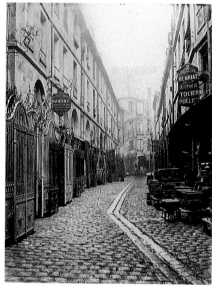

Robert MacPherson
Schottland, 1811-1872

Ansicht des Marcellus Theaters von der Piazza Montanara, Rom
Ca. 1855
Albuminpapier-Abzug vom nassen Kollodium-Glas-Negativ
410 x 276 mm

Ursprünglich zog Robert MacPherson nach Rom, um Landschafts-Malerei zu studieren, doch 1851 begann er zu photographieren. Nach wenigen Jahren gehörte er zu den bekanntesten Photographen Italiens. Bei der Architektur-photographie-Ausstellung von 1862 in London wurden über 400 seiner Arbeiten ausgestellt.

Charles Marville
Frankreich, 1816 – ca. 1879

Passage du Dragon, Paris
Ca. 1865
Albuminpapier-Abzug vom nassen Kollodium-Glas-Negativ
364 x 274 mm

Charles Marville begann 1851 zu photographieren und produzierte in den darauffolgen-den fünf Jahren Papierabzüge von Kathedralen, Schlössern und Städten. 1856 wechselte er vom Mittel des Papier-Negatives zum Glas-Negativ, was kürzere Belichtungszeiten und eine größere Detailtreue ermöglichte.

Robert MacPherson
Scotland, 1811-1872

View of the Marcellus Theatre from the Piazza Montanara, Rome
1855 ca.
Albumen print from wet-collodion glass negative
410 x 276 mm

Robert MacPherson initially moved to Rome to study landscape painting. In 1851, however, he took up photography and within a few years became one of the most accomplished photographers in Italy. Over four hundred of his photographs were exhibited in London by the Architectural Photography Association in 1862.

Charles Marville
France, 1816-1879 ca.

Passage du Dragon, Paris
1865 ca.
Albumen print from wet-collodion glass negative
364 x 274 mm

Charles Marville began photographing in 1851. Over the following 5 years, he made paper negatives of cathedrals, castles and cities. In 1856, Marville joined many of his contempories in the change over from paper to glass negatives, which required shorter exposures and could capture more detail.

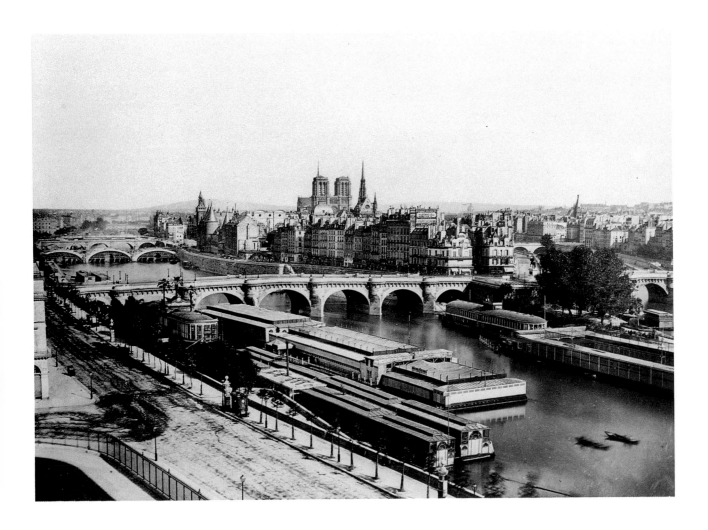

Edouard-Denis Baldus
Frankreich, 1815-1882

*Ansicht des Pont Neuf und der
Ile de la Cité vom Louvre, Paris*
Ca. 1860
Albuminpapier-Abzug vom
nassen Kollodium-Glas-Negativ
200 x 282 mm

Wie eine Reihe von Photogra-
phen der Frühzeit begann auch
Edouard-Denis Baldus als Maler.
In den 40er Jahren wurden seine
Gemälde in den Pariser Salons
ausgestellt. Um 1848 begann er
zu photographieren; 1851 wurde
er von der „Commission des
Monuments Historiques" als
eines von fünf Mitgliedern der
'Mission Héliographique'

bestimmt. Die Arbeitsgruppe
sollte das architektonische Erbe
Frankreichs dokumentieren.
Region um Region sollte bearbei-
tet werden; Baldus beschäftigte
sich mit den Provinzen Burgund,
der Dauphiné und der Provence,
eine Aufgabe, die in der Folge
von anderen Kommissionen
fortgesetzt werden sollte.

Edouard-Denis Baldus
France, 1815-1882

*View of Pont Neuf
and Ile de la Cité from the
Louvre, Paris*
1860 ca.
Albumen print from
wet-collodion glass negative
200 x 282 mm

Like many photographers of the
early period, Baldus began
his career as a painter,
exhibiting his work in the Paris
Salons in the 1840's. In 1848,
he began photographing and, in
1851 the "Commission des
Monuments Historiques"
selected him as one of the five
photographers to form the
'Mission Héliographique'.

The purpose of the Mission was
to document the architectural
heritage of France region by
region. Baldus was assigned
the provinces of Burgundy, the
Dauphiné and Provence. Further
commissions were to shape his
career during the decade.

Eugène Durieu
Frankreich, 1800-1874

Aktstudie
Ca. 1854
Albuminpapier-Abzug vom
nassen Kollodium-Glas-Negativ
200 x 130 mm

Jean-Louis-Marie-Eugène
Durieu wurde in Nîmes geboren.
Nach jahrelanger Beschäftigung
mit der Photographie als
Amateur ließ sich der in Paris
praktizierende Anwalt in den
frühen Ruhestand versetzen
und widmete sich ausschließ-
lich der Photographie, die er so
charakterisierte: „Die Linse ist
ein Instrument; sie kann nur

das festhalten, was sie sieht.
Es liegt am Photographen, sie
das sehen zu lassen, was er sie
sehen lassen will".
Diese Aktstudie ist Teil einer
1853 bis 1854 entstandenen
Serie, die er in Zusammenarbeit
mit seinem Freund, dem Maler
Eugène Delacroix, in dessen
Atelier aufnahm.

Eugène Durieu
France, 1800-1874

Nude Study
1854 ca.
Albumen print from
wet-collodion glass negative
200 x 130 mm

Jean-Louis-Marie-Eugène
Durieu was born in Nîmes and
later practiced law in Paris.
After years of photographing as
an amateur, he went into early
retirement so he could devote
himself iompletely to
photography. This print is from
a series of nude photographs
taken in the years 1853-1854 in
collaboration with Durieu's

good friend, Eugène Delacroix.
Durieu said of photography.
"The lens is an instrument; it
can only record what it sees,
but it is up to the photographer
to make it see what he wants
it to".

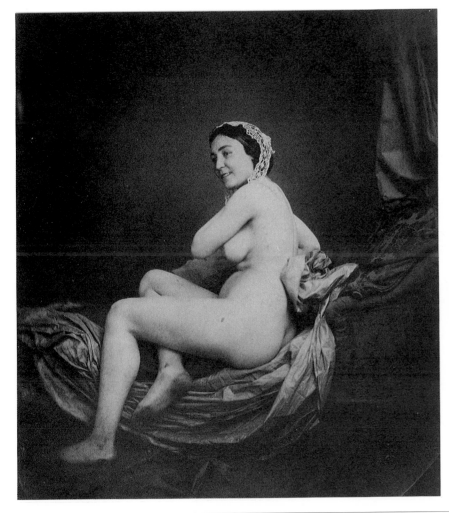

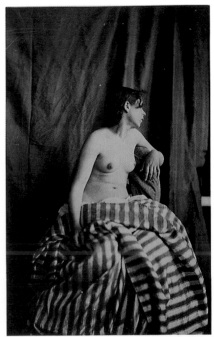

Auguste Belloc
Frankreich, ?-1867

„Etude de femme"
Ca. 1855
Salzpapier-Abzug vom
Glas-Negativ
196 x 170 mm

Nebst seiner Tätigkeit als Maler
künstlerischer Portraits
widmete sich Auguste Belloc
als Amateur der Photographie,
innerhalb derer er mit Aktauf-
nahmen hervortrat, die durch
voluminöse Draperie auffallen.

Eugène Durieu
Frankreich, 1800-1870

Akt in Delacroix's Atelier
Ca. 1853
Albuminpapier-Abzug vom
nassen Kollodium-Glas-Negativ
207 x 130 mm

Auguste Belloc
France, ?-1867

"Etude de Femme"
1855 ca.
Salt print from glass negative
196 x 170 mm

In addition to taking artistic
portraits in his studio, Belloc
also taught amateurs interested
in photography.
He is best known for his nude
photographs which are
generally characterized by the
atmosphere created by the use
of voluminous drapes.

Eugène Durieu
France, 1800-1870

Nude in Delacroix's Studio
1853 ca.
Albumen print from
wet-collodion glass negative
207 x 130 mm

John Francis Michiels
Belgien, 1823-1887

Der Kölner Dom im Bau
1853
Salzpapier-Abzug vom
Wachspapier-Negativ
540 x 430 mm

Geboren im belgischen Brügge
wurde John Francis Michiels
1855 preußischer Bürger und
ließ sich in Köln nieder. Er gilt
als bedeutendster Dokumentator
des Baus des Kölner Doms, der
größten gotischen Kirche
Deutschlands, deren Grundstein
1248 gelegt worden war.
Einige Alben mit seinen Photo-
graphien wurden von Franz

Eisen publiziert unter dem
Titel *Kölner Bauwerke in
Deutschland von Michiels.*

John Francis Michiels
Belgium 1823-1887

*Cologne Dome under
Construction*
1853
Salt print from waxed-paper
negative
540 x 430 mm

Although born in Brugge,
Belgium, Michiels became a
Prussian citizen in 1855, settling
in Cologne. He is considered
the most important
photographer to document the
construction of the cologne
Dome. Several albums
containing his photographs
were published by Franz Eisen
entitled, *Kölner Bauwerke in*

Deutschland von Michiels.
Work on the Cologne Dome,
the largest gothic church
in Germany, began in 1248.

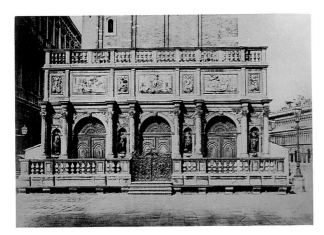

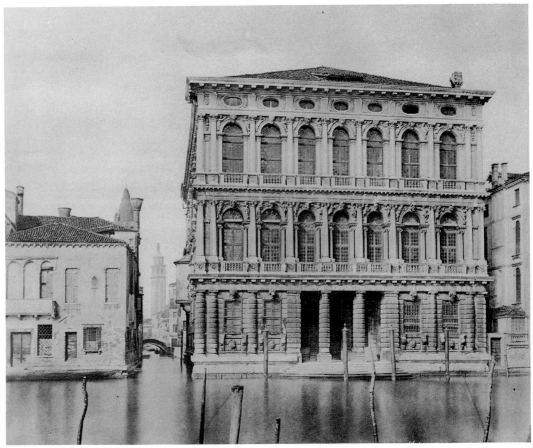

Jacob August Lorent
Deutschland, 1813-1884

„Logetta del Campanile di San Marco", Venedig
1853
Salzpapier-Abzug vom Wachspapier-Negativ
325 x 470 mm

Jacob August Lorent
Deutschland, 1813-1884

Palazzo Rezzonico, Venedig
1853
Salzpapier-Abzug vom Wachspapier-Negativ
380 x 480 mm

1853 begann Jacob August Lorent zu photographieren und war bald einer der ersten deutschen Photographen, die internationale Anerkennung fanden. Die abgebildete Aufnahme ist Teil einer in Venedig entstandenen Serie, für die er anläßlich einer Ausstellung bei der Münchner Industriemesse von 1854 eine Gold-Medaille erhielt und bei der „Exposition Universelle" in Paris 1855 ausgezeichnet wurde.

Jacob August Lorent
Germany, 1813-1884

"Logetta del Campanile di San Marco", Venice
1853
Salt print from waxed-paper negative
325 x 470 mm

Jacob August Lorent
Germany, 1813-1884

Palazzo Rezzonico, Venice
1853
Salt print from waxed-paper negative
380 x 480 mm

Lorent took up photography in 1853 and was one of the first Germans to gain international recognition.
This photograph is one of a series taken in Venice for which he won a gold medal at the Industrial Exhibition in Munich in 1854 and a first-class medal in Paris at the Exposition Universelle in 1855. "His views of Venice, taken, we believe, with waxed-paper negatives, have an amplitude, a harmony, a vigor, that make the works magisterial... Independent of their exceptional dimensions, the views have a grandeur, and one finds in them all the heat of the beautiful Adriatic sun. M. Lorent is the Venetian Baldus" (Ernst Lacan).

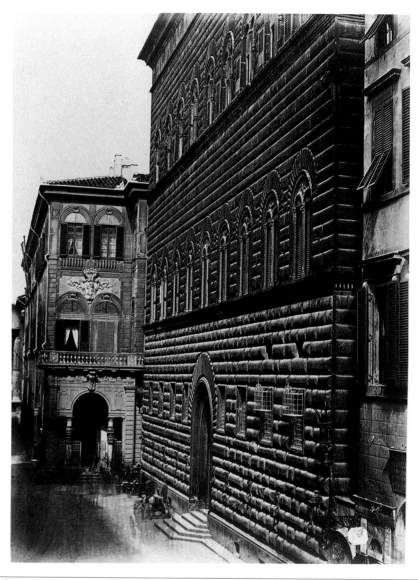

Fratelli Alinari
Italien

Sexta des Palazzo Grottanelli, Siena
Ca. 1855
Albuminpapier-Abzug vom nassen Kollodium-Glas-Negativ
344 x 263 mm

Fratelli Alinari
Italien

Palazzo Strozzi und Palazzo Corsi, Florenz
Ca. 1855
Albuminpapier-Abzug vom nassen Kollodium-Glas-Negativ
348 x 258 mm

Mit Hilfe seines Lehrmeisters, dem Kupferstecher Luigi Bardi, gründete Leopoldo Alinari (1832-1865) zwanzigjährig in Florenz 1852 ein photographisches Atelier. Seine frühen Arbeiten können durch einen Prägestempel Luigi Bardis identifiziert werden. 1854 stießen seine zwei Brüder Romualdo (1830-1891) und

Giuseppe (1836-1891) hinzu: Die Firma „Fratelli Alinari" war gegründet.

Fratelli Alinari
Italy

Sexta del Palazzo Grottanelli, Siena
1855 ca.
Albumen print from wet-collodion glass negative
344 x 263 mm

Fratelli Alinari
Italy

Palazzo Strozzi and Palazzo Corsi, Florence
1855 ca.
Albumen print from wet-collodion glass negative
348 x 258 mm

In 1852, at the age of 20, Leopoldo Alinari set up a photographic studio in Florence with the help of his former instructor, the engraver Luigi Bardi. Early Alinari photographs are identified by a blindstamp with Bardi's name. Two years later, the three brothers Leopoldo (1832-1865), Romualdo (1830-1891) and

Giuseppe (1836-1891) founded the company "Fratelli Alinari".

Leopold Arendts
Deutschland

Das Brandenburger Tor, Berlin
Ca. 1855
Salzpapier-Abzug vom
Glas-Negativ
160 x 220 mm

Leopold Arendts
Germany

The Brandenburger Gate, Berlin
1855 ca.
Salt paper print from a glass
negative
160 x 220 mm

62 **Félix Jaques-Antoine Moulin**
Frankreich, 1800- ca. 1868

„Etude Photographique"
Ca. 1852
Salzpapier-Abzug vom
Glas-Negativ
220 x 165 mm

Félix Moulin gewann das
Interesse der zeitgenössischen
Kritiker mit seinen in klassischen
Posen photographierten
Aktstudien. Seine Frau und
seine Tochter standen ihm
gewöhnlich Modell und sind
vermutlich auch auf diesem
Photo zu sehen.

Félix Jacques-Antoine Moulin
France, 1800-1868 c.

"Etude Photographique"
1852 ca.
Salt print from glass negative
220 x 165 mm

Moulin is best known for his
studies of nudes photographed
in classical poses, which were
highly regarded by critics of the
day. His wife and daughter
were not unaccustomed to
modelling for him, and are
thought to be the subjects in
this photograph.

William Henry Lake Price
England, 1810-1896

„Don Quixote"
1855
Photogalvanographie von
Paul Pretsch, 1856
225 x 200 mm

William Lake Price, Mitglied der „Old Watercolour Society" (die zwischen 1837 und 1852 zweiundvierzig seiner Gemälde ausstellte), spiegelte in seinem „Don Quixote" besonders deutlich die viktorianische Vorliebe für antiquarisches, antikisierendes Interieur: Objekte und Waffen dienen seiner Inszenierung der Photo-graphie ebenso wie derjenigen der damaligen Malerei.
Der Österreicher Paul Pretsch war Direktor der Staatsdruckerei in Wien. 1854 entwickelte er die Photogalvanographie.

William Henry Lake Price
England, 1810-1896

"Don Quixote"
1855
Photogalvanograph by Paul Pretsch, 1856
225 x 200 mm

Lake Price was a member of the Old Watercolour Society and exhibited fourty-two paintings there between 1837 and 1852. His "Don Quixote" reflects the Victorian fashion for antiquarian interiors, and its collection of objects and armour echoes contemporary paintings of similar subject matter.
Paul Pretsch, an Austrian, was the director of the Staatsdruckerei in Vienna. In 1854, he developed an electro-engraving process which he called photogalvanography.

64 **Félix Nadar**
 Frankreich, 1820-1910

 Frederike O'Connell, Paris
 Ca. 1855
 Salzpapier-Abzug vom
 Glas-Negativ
 222 x 155 mm

Félix Nadar schätzte die Malerin
Frederike O'Connell (1823-
1885) derart, daß er sie mit der
Kolorierung und dem Retu-
schieren seiner Photographien
beauftragte. Ihre Beiträge
gingen so weit, daß sie
Aufnahmen signierte, beispiels-
weise Nadars Portrait des
Zaren Alexander III.

 Félix Nadar
 France, 1820-1910

 Frederike O'Connell, Paris
 1855 ca.
 Salt print from glass negative
 222 x 155 mm

Félix Nadar so admired the
painter Frederike O'Connell
(1823-1885) that he employed
her for colouring and retouching
his photographs. In fact, her
signature is found on Nadar's
portrait of Czar Alexander III.

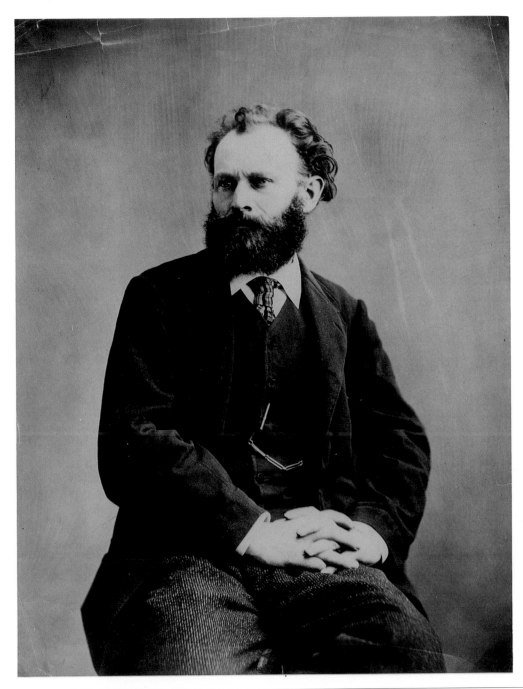

Félix Nadar
Frankreich, 1820-1910

*Edouard Manet (1832-1883),
Paris*
1867
Albuminpapier-Abzug vom
Glas-Negativ
270 x 200 mm

1867 schrieb und publizierte
Emile Zola (1840-1902) ein
kleines Pamphlet: *Edouard
Manet, étude biographique et
critique.* Das Heft wurde
während Manets unabhängiger
Ausstellung in Paris verteilt.
Manet bat den Meisterstecher
Félix Bracquemond, ihm nach
dieser Photographie ein Portrait

für das Frontispiz des Pamphlets
zu stechen.

Félix Nadar
France, 1820-1910

*Edouard Manet (1832-1883),
Paris*
1867
Albumen print from
glass negative
270 x 200 mm

In 1867, Emile Zola (1840-1902)
wrote and published the small
pamphlet: *Edouard Manet,
étude biographique et critique,*
which was to be distributed
during Manet's independent
exhibition in Paris. Manet had
asked the master engraver Félix
Bracquemond to etch a portrait
of him based on this
photograph by Nadar, which

was used as a frontispiece in
Zola's pamphlet.

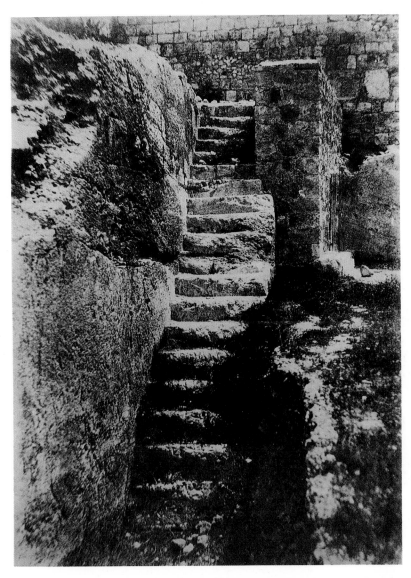

Félix Nadar
Frankreich, 1820-1910

In den Katakomben von Paris
1861
Albuminpapier-Abzug vom
Glas-Negativ
229 x 189 mm

Eine der frühesten Aufnahmen
unter der Erde, unter den
Straßen von Paris: Künstliches
Licht hatte sie möglich gemacht.
Für Nadar eine faszinierende
Arbeit: „Der Untergrund bietet
nicht weniger als die Oberwelt:
eine endlose Folge interessanter
Entdeckungen".

August Salzmann
Deutschland, 1824-1872

Antike Steintreppe, Jerusalem
1854
Salzpapier-Abzug von
Blanquart-Evrard (Lille) vom
Wachspapier-Negativ
330 x 235 mm

August Salzmanns Karriere als
Photograph begann, als er nach
Jerusalem reiste, um einige
Bauwerke aufzunehmen.
Seine Dokumente sollten als
Argumentationshilfen in einem
Disput um Datierungsfragen
dieser Monumente dienen, die
der Archäologe Louis-Félicien-
Joseph Caignart de Sauley
(1807-1880) klären wollte.

Félix Nadar
France, 1820-1910

In the Catacombes of Paris
1861
Albumen print from glass
negative
229 x 189 mm

This is one of the first
photographs taken under the
streets of Paris, made possible
by the use of artificial light.
Nadar said of his work,
"the world underground offered
as much as the world
on the surface: an endless
stream of interesting
discoveries".

August Salzmann
Germany, 1824-1872

*Ancient Stairway
cut into Stone, Jerusalem*
1854
Salt print by Blanquart-Evrard
(Lille) from waxed-paper
negative
330 x 235 mm

Salzmann's career as a
photographer began when he
went to Jerusalem in order to
take pictures of certain
monuments which were the
subject of a dispute concerning
dating schemes established by
the archeologist Louis-Félicien-
Joseph Caignart de Sauley
(1807-1880).

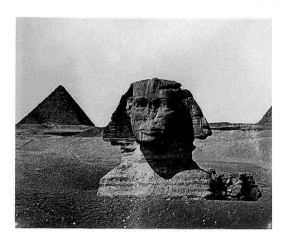

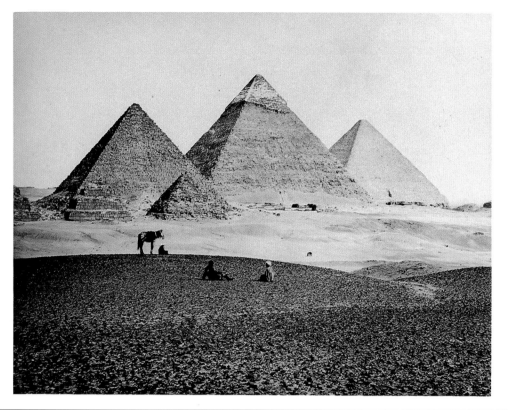

<table>
<tr><td>68</td><td></td></tr>
</table>

Francis Frith England, 1822-1898 *Die Pyramiden von Gizeh, Ägypten* 1858 Albuminpapier-Abzug vom nassen Kollodium-Glas-Negativ 362 x 480 mm	Francis Frith begann 1850 zu photographieren. Ab 1856 bereiste er jährlich Ägypten und brachte Aufnahmen nach London mit, die auf ein sehr interessiertes britisches Publikum stießen. Mit einer drängenden Nachfrage im Rücken, publizierte und verkaufte Frith seine Photo- graphien selbst.	**W. Hammerschmidt** Deutschland *Sphinx und dritte Pyramide von Gizeh, Ägypten* Ca. 1858 Albuminpapier-Abzug vom nassen Kollodium-Glas-Negativ 240 x 315 mm	Der in Berlin geborene Ham- merschmidt erscheint auf der Mitgliederliste der Französischen Gesellschaft für Photographie. Von ihm sind Photographien erhalten, die in den späten 50er bis in die 70er Jahre des 19. Jahrhunderts in Ägypten entstanden sind.
Francis Frith England, 1822-1898 *The Pyramids of Giza, Egypt* 1858 Albumen print from wet-collodion glass negative 362 x 480 mm	Francis Frith began taking photographs in 1850. By 1856 he was sufficiently well established to finance the first of several trips to Egypt. Due to the overwhelming public interest in his work, Frith successfully published and sold his photographs.	**W. Hammerschmidt** Germany *Sphinx and Third Pyramid of Giza, Egypt* 1858 ca. Albumen print from wet-collodion glass negative 240 x 315 mm	Born in Berlin, Hammerschmidt photographed in Egypt in the late 1850's until sometime in the 1870's. He appears in the list of members of the Société Française de Photographie.

John Bulkley Greene
Vereinigte Staaten von Amerika,
1832-1856

Die Gräber der Kalifen, Kairo
Ca. 1854
Salzpapier-Abzug von
Blanquart-Evrard (Lille) vom
Wachspapier-Negativ
223 x 300 mm

John Bulkley Greene ist be-
kannt durch die Photographien,
die er während einiger Expedi-
tionen in Nord-Afrika aufnahm.
1854 publizierte Blanquart-Ev-
rard in Lille ein Buch mit 94
seiner Salzpapier-Abzüge:
*Le Nil, Monuments, Paysages,
Explorations Photographiques
par J.B. Greene.*

Greene wählte nicht die
konventionellen Sujets,
sondern bevorzugte poetische
Ansichten des Gebietes um
den Nil und in der Wüste, oder
er wählte archäologisch interes-
sante Bauwerke. Er starb,
vierundzwanzigjährig, während
seiner Arbeit in Algerien.

John Bulkley Greene
United States, 1832-1856

Caliph Graves, Cairo
1854 ca.
Salt print by Blanquart-Evrard
(Lille) from waxed-paper
negative
223 x 300 mm

John Bulkley Greene is best
known for his photographs
taken while on expeditions to
North Africa. In 1854, Blanquart-
Evrard (Lille) published *Le Nil,
Monuments, Paysages,
Explorations Photographiques
par J.B. Greene,* a book
containing 94 salt prints.
Greene's work does not include
conventional images of favourite

tourist sites. He prefered to
photograph poetic views of the
Nile or the empty desert, as
well as archeologically important
monuments. Greene died while
working in Algeria at the age
of twenty-four.

Comte Olympe Aguado
Frankreich, 1827-1894

Waldweg
Ca. 1855
Albuminpapier-Abzug vom
nassen Kollodium-Glas-Negativ
272 x 395 mm

Comte Olympe Aguado wurde
von Jules Ziégler 1855 als einer
der bedeutendsten Vertreter
seiner Generation beschrieben,
„die diese neue Kunst aufnah-
men, indem sie ihr nicht nur
ihre Energie und ihr Geld,
sondern ihr ganzes Leben
widmeten".

Comte Olympe Aguado
France, 1827-1894

Forest Path
1855 ca.
Albumen print from
wet-collodion glass negative
272 x 395 mm

Comte Olympe Aguado was
described by Jules Ziégler in
1855 as among the eminent
men of his generation who
"welcomed the new art and
devoted to it not only their
energy and money but their
fortunes and their lifetimes".

Adolphe Braun
Frankreich, 1812-1877

*„Fleurs des Champs
d'après Nature"*
1854
Albuminpapier-Abzug vom
nassen Kollodium-Glas-Negativ
400 x 477 mm

1854 publizierte Adolphe Braun
ein Album mit Abzügen von
Blumenmustern, die ein Jahr
darauf bei der 'Exposition
Universelle' in Paris ausgestellt
wurden. Er wurde mit einer
Gold-Medaille ausgezeichnet
für die Vielfalt seiner Aufnah-
men und deren großen Nutzen
für die Textil-Industrie. Kurz
darauf gab er das Textil-Design

zugunsten der Photographie
auf und betrieb bald eines der
größten Ateliers der Welt.
Braun wurde Hof-Photograph
von Napoleon III.

Adolphe Braun
France, 1812-1877

*"Fleurs des Champs
d'après Nature"*
1854
Albumen print from
wet-collodion glass negative
400 x 477 mm

In 1854, Adolphe Braun
published an album of original
floral designs, prints of which
were subsequently displayed
at the Exhibition Universelle,
Paris, in 1855. He was awarded
a gold medal for their variety
and for the usefulness of his
images to the textile industry.
Not long after, Braun gave up
textile design to devote himself

entirely to photography, and
soon ran one of the largest
studios in the world. He was
the official photographer
to the Court of Napoleon III.

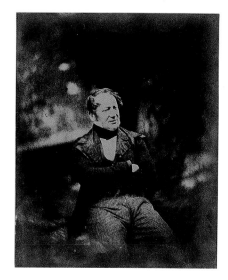

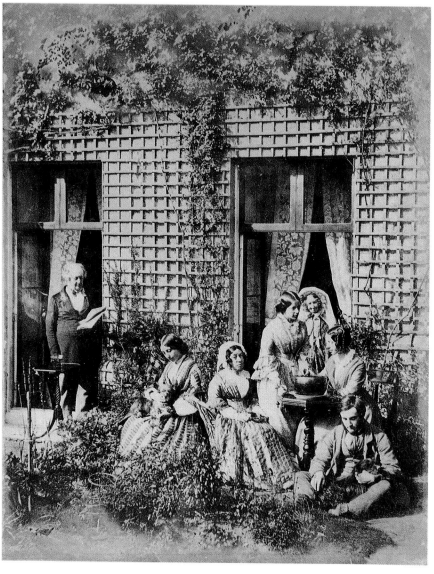

72

Nevil Story Maskelyne
England, 1823-1911

Professor Baden-Powell, Oxford
Ca. 1845
Salzpapier-Abzug vom
Papier-Negativ
220 x 182 mm

Nevil Story Maskelyne
England, 1823-1911

„At Basset Down"
1855
Salzpapier-Abzug vom
Glas-Negativ
144 x 120 mm

Nevil Story Maskelyne
verbrachte seine produktivste
Zeit als Photograph auf dem
Familiensitz seiner Eltern, in
Basset Down unweit Talbots
Lacock Abbey in Wiltshire. Er
war zu der Zeit an der Universität
Oxford immatrikuliert, wo er
viele seiner Professoren und
Kollegen photographierte. Die
Aufnahme „At Basset Down"

zeigt Maskelynes Vater,
Anthony Story, der der versam-
melten Familie aus der *Times*
einen Bericht über den Fall von
Sewastopol vorliest.

Nevil Story Maskelyne
England, 1823-1911

Professor Baden-Powell, Oxford
1845 ca.
Salt print from paper negative
220 x 182 mm

Nevil Story Maskelyne
England, 1823-1911

"At Basset Down"
1855
Salt print from glass negative
144 x 120 mm

Nevil Story Maskelyne spent his
most productive years as a
photographer while living at his
parents' home at Basset Down
which, incidently, was not far
from W.H.F. Talbot's Lacock
Abbey in Wiltshire. At the same
time, he studied at Oxford
where he photographed many
of his professors and fellow
students.

This photograph was taken as
his father, Anthony Story, was
reading from *The Times,*
the news of the fall of
Sebastopol to the gathered
members of his family.

Nevil Story Maskelyne
England, 1823-1911

„Group of Hands"
Ca. 1855
Albuminpapier-Abzug vom
nassen Kollodium-Glas-Negativ
140 x 145 mm

Ziemlich sicher ist diese
Aufnahme eher Schnappschuß
denn arrangierte Komposition.
Sie entstand vermutlich bei
einer Hochzeit oder einem
vergleichbaren familiären
Ereignis. Da das Glas-Negativ
zerbrochen war, vignettierte
Maskelyne den Abzug.

Nevil Story Maskelyne
England, 1823-1911

"Group of Hands"
1855 ca.
Albumen print from
wet-collodion glass negative
140 x 145 mm

It seems almost certain that this
photograph was a "snap shot"
rather than a composed study.
It was probably taken at a
wedding or similar family
occasion. Maskelyne vignetted
the print to conceal the damage
resulting from the glass
negative breaking.

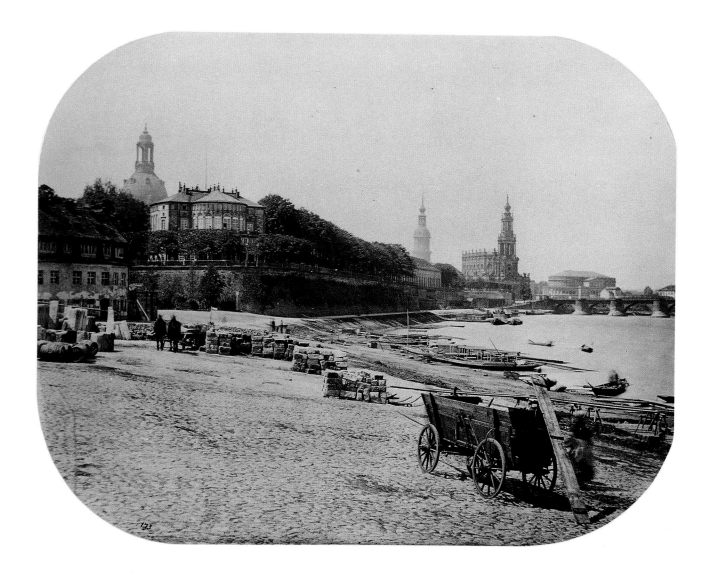

74 **Hermann Krone**
Deutschland 1827-1916

*Die Brühlsche Terrasse in
Dresden*
Ca. 1857
Albuminpapier-Abzug vom
nassen Kollodium-Glas-Negativ
400 x 320 mm

Hermann Krone ist als Portraitist
bekannt. Die Kommerzialität
seiner Aufnahmen und seines
Ateliers kommt im Stempel auf
den Passepartouts seiner
Photographien zum Ausdruck,
wo er sein Atelier als „Photo-
graphische Kunstanstalt für
Portraits und Landschaften"
bezeichnet. Krone zeichnete
für eine Reihe technischer

Entwicklungen des Mediums
verantwortlich und fand viel
Anerkennung.

Hermann Krone
Germany, 1827-1916

*The Brühlsche Terrace in
Dresden*
1857 ca.
Albumen print from
wet-collodion glass negative
400 x 320 mm

Hermann Krone is best known
as a portraitist. The commercial
nature of his photographs and
publishing studio is indicated
by the information printed on
the mounts of his photographs,
where he refers to his studio as
a "photographic artistic
etablishment for portraiture
and landscape". Krone was
responsible for many technical

advances in the medium and he
was awarded many honours.

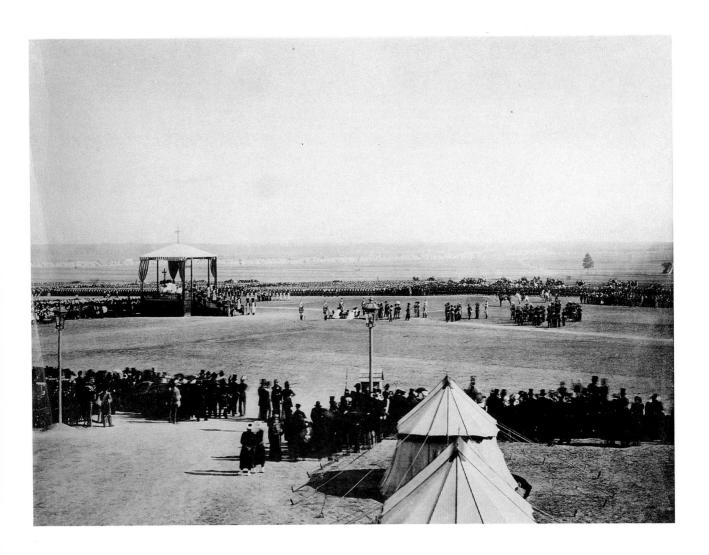

Gustave Le Gray
Frankreich, 1820-1882

Messe für Napoleon I.,
Camp de Châlons
1857
Albuminpapier-Abzug vom
nassen Kollodium-Glas-Negativ
295 x 365 mm

Gustave Le Gray studierte bei
Picot und Delaroche Malerei.
1848 eröffnete er ein Atelier für
Photographie im selben Haus,
in dem die Bisson-Brüder
arbeiteten und verdiente
seinen Lebensunterhalt vorwie-
gend mit Portrait-Aufnahmen.
Seine hervorragendsten Bilder
sind in der Umgebung von
Fontainebleau entstanden,

sind Aufnahmen des Meeres
und des Militär-Alltags in
Châlons. Zwischen 1856 und
1870 pflegte Napoleon III. den
Geburtstag Napoleon I. im
Kreise seiner Soldaten zu feiern;
am 15. August 1857 photo-
graphierte Le Gray die Messe
zu Ehren des Geburtstages, die
auf dem „Camp de Châlons"
gelesen wurde.

Kaiserin Eugénie ist in der
Bildmitte sitzend abgebildet.

Gustave Le Gray
France, 1820-1882

Mass for Napoleon I.,
Camp de Châlons
1857
Albumen print from
wet-collodion glass negative
295 x 365 mm

Le Gray, who started his career
as a painter studying under
Picot and Delaroche, opened a
photography studio in 1848 in
the same building as the Bisson
brothers, and made a living
mainly by taking portraits.
Photographs of the
Fontainebleau countryside, of
seascapes, and of military life at
the Châlons Barracks, however,

comprise his most significant
work. In the years from 1856 to
1870, Napoleon III. had become
accustomed to celebrating the
birthday of Napoleon I. amongst
his fellow officers. On August
15, 1857, Le Gray took this
photograph at a Mass,
celebrated in honour of the
birthday.
Empress Eugénie can be seen

seated in the middle of the
picture.

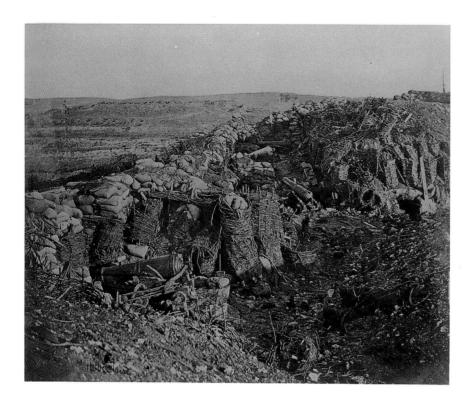

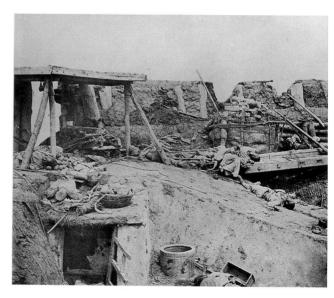

James Robertson
Schottland, 1813-?

*Schützengraben in Redan,
Sewastopol (Krim-Krieg)*
1855
Salzpapier-Abzug vom
Glas-Negativ
225 x 280 mm

James Robertson begann
seine Karriere als Kunststecher.
Er heiratete Marie Matilda
Beato und begann 1850 mit
Hilfe ihres Bruders Felice Beato
Kalotypien herzustellen. Die
beiden reisten und arbeiteten
in der Folge zusammen,
ersetzten dann vermutlich das
Kalotypie-Verfahren durch das
Albumin-auf-Glas-Verfahren.

Robertson wurde bekannt
durch seine Aufnahmen des
Krim-Krieges, speziell der-
jenigen, die nach dem Fall von
Sewastopol am 5. September
1855 entstanden. Eine ganze
Reihe von Robertson
zugeschriebenen Aufnahmen
dürften von Beato aufge-
nommen worden sein.

Felice Beato
Italien (naturalisierter
britischer Bürger), 1830-1903

*Das North Taku Fort bei Tientsin,
China*
1860
Albuminpapier-Abzug vom
nassen Kollodium-Glas-Negativ
242 x 292 mm

James Robertson
Scotland, 1813-?

*Entrenchments at Redan,
Sebastopol (Crimean War)*
1855
Salt print from glass negative
225 x 280 mm

James Robertson began his
career as an engraver.
He married Marie Matilda
Beato, and began
photographing in 1850, making
calotypes with Felice Beato's
help. Later the two travelled and
worked together, eventually
changing from calotypes to the
albumen-on-glass process.
Although Robertson is well

known for his pictures of the
Crimean War, especially those
after the fall of Sebastopol on
September 5, 1855, it is thought
that many of the photographs
attributed to Robertson were
actually taken by Beato.

Felice Beato
Italy (naturalized British citizen),
1830-1903

*The North Taku Fort near
Tientsin, China*
1860
Albumen print from
wet-collodion glass negative
242 x 292 mm

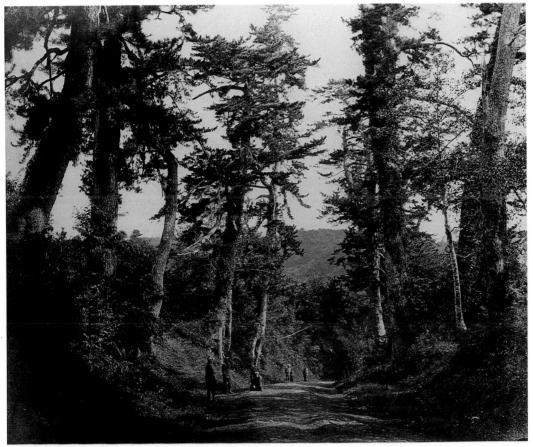

Felice Beato
Italien (naturalisierter britischer Bürger), 1830-1903

Der Tokaido, Japan
1868
Albuminpapier-Abzug vom nassen Kollodium-Glas-Negativ
222 x 278 mm

Felice Beato, vermutlich in Venedig geboren, arbeitete mit seinem Schwager James Robertson während des Krim-Krieges zusammen, sowie in Konstantinopel, Indien, Athen, Ägypten und Palästina. Nachdem er die Meuterei der Sepoys (Indien) von 1857-1859 photographiert hatte – Robertson war offizieller

Photograph der britischen Militärstreitkräfte –, arbeitete Beato halboffiziell als Photograph des anglo-französischen Expeditions-Korps in Nord-China. Im Anschluß gelangte er nach Japan, wo er viele Jahre lebte und arbeitete.

Felice Beato
Italien (naturalisierter britischer Bürger), 1830-1903

Kaiserliche Gräber, Peking
1860
Albuminpapier-Abzug vom nassen Kollodium-Glas-Negativ
233 x 285 mm

Felice Beato
Italy (naturalized British citizen), 1830-1903

The Tokaido, Japan
1868
Albumen print from wet-collodion glass negative
222 x 278 mm

Felice Beato, reportedly born in Venice, worked with James Robertson during the Crimean War and later in Constantinopole, India, Athens, Egypt and Palestine.
After photographing the Indian Mutiny (1857-1859), Beato arrived in China in 1860 as the semi-official photographer of the Anglo-French North

China Expeditionary Force. He then moved to Japan where he lived and worked for many years.

Felice Beato
Italy (naturalized British citizen), 1830-1903

Imperial Graves, Peking
1860
Albumen print from wet-collodion glass negative
233 x 285 mm

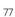

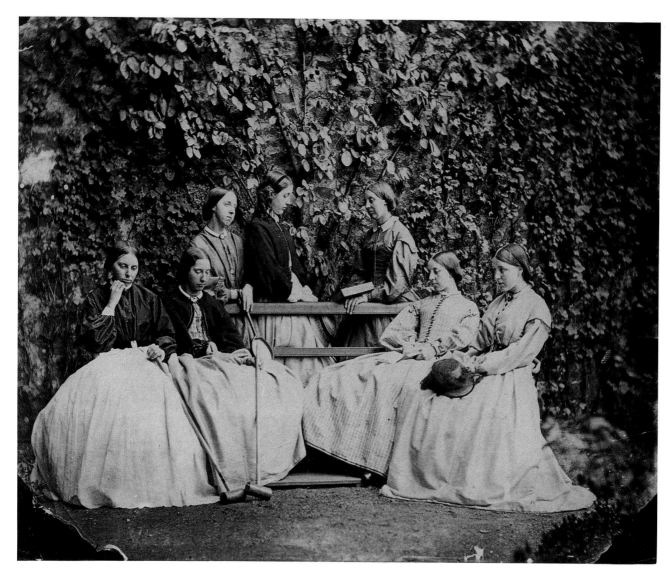

Lewis Carroll
(Charles Lutwidge Dodgson)
England, 1832-1898

*Die sieben Schwestern von
Lewis Carroll*
Ca. 1860
Albuminpapier-Abzug vom
nassen Kollodium-Glas-Negativ
200 x 246 mm

Charles Lutwidge Dodgson, ein
hervorragender Professor der
Mathematik in Oxford, schrieb
unter dem Pseudonym Lewis
Carroll die berühmte Geschichte
der *Alice im Wunderland.*
Dem begabten Amateur-Photo-
graphen lagen besonders
Kinder-Portraits. Die Inspiration
zu seiner Alice kam, als er
Modelle für seine Photographien

suchte und Alice Liddell fand.
Er hörte 1880 auf zu photo-
graphieren, vermutlich auch
deshalb, weil er mit dem
Aufkommen des Trockenplatten-
Verfahrens nicht glücklich
werden wollte: Carroll fand das
neue, bald weit verbreitete
Verfahren unkünstlerisch.

Lewis Carroll
(Charles Lutwidge Dodgson)

*The Seven Sisters
of Lewis Carroll*
1860 ca.
Albumen print from
wet-collodion glass negative
200 x 246 mm

Charles Lutwidge Dodgson was
a distinguished mathematics
professor at Oxford who, under
the pseudonym of Lewis
Carroll, wrote *Alice in
Wonderland* (1866). He was
also a gifted amateur
photographer with a particularly
original approach to children's
portraiture. In fact, he met Alice
Liddell, the inspiration for his

novel, while looking for young
photographic models. He gave
up photography in 1880,
possibly because of the
introduction of the dry-plate
process which he thought
unartistic.

Lewis Carroll
(Charles Lutwidge Dodgson)
England, 1832-1898

Portrait von Hallam Tennyson
28. September 1857
Albuminpapier-Abzug vom
nassen Kollodium-Glas-Negativ
122 x 102 mm

Ludwig Angerer
Österreich, 1827-1879

Theatergruppe, Wien
Ca. 1857
Albuminpapier-Abzug vom
nassen Kollodium-Glas-Negativ
214 x 275 mm

Der in Ungarn geborene
Optiker Ludwig Angerer
begann als Amateur-Photo-
graph, doch 1860 war aus dem
Hobby Profession geworden,
er wurde Hof-Photograph in
Wien.

Lewis Carroll
(Charles Lutwidge Dodgson)
England, 1832-1898

Portrait of Hallam Tennyson
September 28, 1857
Albumen print from
wet-collodion glass negative
122 x 102 mm

Ludwig Angerer
Austria, 1827-1879

Theatre Troop, Vienna
1857 ca.
Albumen print from
wet-collodion glass negative
214 x 275 mm

Originally an optician, Angerer,
born in Hungary, began
photographing as an amateur.
By 1860, however, his hobby
had developed into a skill and
he was named court
photographer in Vienna.

 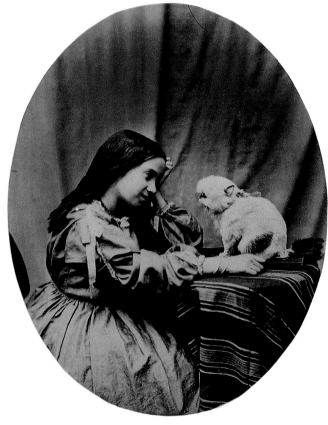

Oscar Gustav Rejlander
Schweden, 1813-1875

Miss Virginia Dalrymple
Ca. 1865
Albuminpapier-Abzug vom
nassen Kollodium-Glas-Negativ
185 x 145 mm

Oscar Gustav Rejlander
Schweden, 1813-1875

*Miss Isabel Somers Cocks
(Nichte der Julia Margaret
Cameron)*
Ca. 1852
Albuminpapier-Abzug vom
nassen Kollodium-Glas-Negativ
200 x 160 mm

Bevor er sich schließlich in
England niederließ, lernte der
in Schweden geborene Oscar
Gustav Rejlander in Rom die
Malerei. In einigen seiner
photographischen Portraits
schimmern prä-Raffaelitische
Auffassungen durch. Die
Kompositionen seiner
Aufnahmen, ihre ausgewogenen
Arrangements lassen Rejlanders

Ausbildung spüren, vermitteln
die Spuren seiner Jahre, die er
mit dem Kopieren der alten
Meister verbracht hatte.
Man kann glauben, daß sein Stil
Einfluß auf Julia Margaret
Cameron hatte.

Oscar Gustav Rejlander
Sweden, 1813-1875

Miss Virginia Dalrymple
1865 ca.
Albumen print from wet-
collodion glass negative
185 x 145 mm

Oscar Gustav Rejlander
Sweden, 1813-1875

*Miss Isabel Somers Cocks
(Neice of Julia Margaret
Cameron)*
1852 ca.
Albumen print from
wet-collodion glass negative
200 x 160 mm

Born in Sweden, O.G. Rejlander
trained as a painter in Rome
before settling in England. In
certain of his portraits, Rejlander
expresses a feeling reminiscent
of pre-Raphaelitism. Composite
photographs, with their
balanced arrangements of
sculptural forms, often suggest
the rules of the Academy and,
in Rejlander's case bespeak the

years spent copying old
masters in Rome. His portraits
are believed to have influenced
Julia Margaret Cameron.

Milton M. Miller
Vereinigte Staaten von Amerika

*Chinesische Dame
von Szechuan*
Ca. 1862
Albuminpapier-Abzug vom
nassen Kollodium-Glas-Negativ
170 x 165 mm

Milton M. Miller arbeitete in
Hong Kong und Kanton von
1861 bis 1864 als Portrait-
Photograph. Seine Aufnahmen
offizieller und nicht-offizieller
Persönlichkeiten des
chinesischen Lebens gehören
zu den wichtigsten, China
dokumentierenden Arbeiten
des 19. Jahrhunderts.

Milton M. Miller
United States

Chinese Lady from Szechuan
1862 ca.
Albumen print from wet-
collodion glass negative
170 x 165 mm

Milton M. Miller was active in
Hong Kong and Canton from
1861 to 1864, his forte being the
studio portraiture of official and
non-official Chinese
personalities. Besides being
beautifully realized portraits,
these images and the series
which they comprise, are the
most important documentary
photographs taken in China
during the 19th century. Despite
the limitations of mutual Sino-
European bigotry, primitive
equipment, and slow
photographic emulsions,
Miller's studio portraits convey
a distinct modernity.

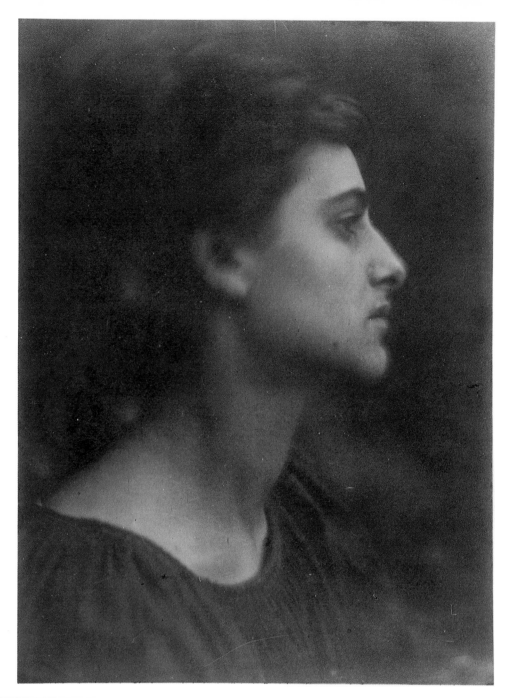

82 **Julia Margaret Cameron**
England, 1815-1879

*„The Beautiful Browed Œnone"
(Dieser Abzug ist Gustave
Doré gewidmet)*
1872
Albuminpapier-Abzug vom
Glas-Negativ
354 x 225 mm

Aus einem Brief Julia Margaret
Camerons an Sir John Herschel
vom 31. Dezember 1864:
„Mein Bestreben ist es, die
Photographie zu veredeln und
ihr den Charakter und die
Wirkung einer Hohen Kunst zu
sichern, indem ich das Wirkli-
che und das Ideale verbinde
und bei aller Verehrung für

Poesie und Schönheit von der
Wahrheit nichts opfere..."

Julia Margaret Cameron
England, 1815-1879

*"The Beautiful Browed Œnone"
(print dedicated to Gustave
Doré)*
1872
Albumen print from
glass negative
354 x 225 mm

Julia Margaret Cameron wrote
in *The Annals of my Glass
House* (1874), "My first
successes, my out-of-focus
pictures, were a fluke: that is to
say, that when focusing
and coming to something
which to my eye was very
beautiful. I stopped there
instead of screwing on the lens
to the more definite focus

which all other photographers
insist upon".

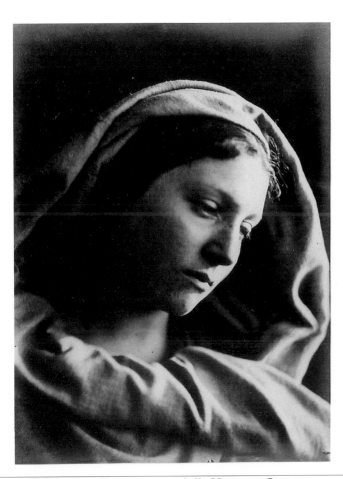

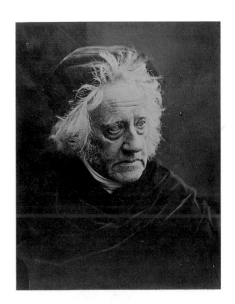

Julia Margaret Cameron
England, 1815-1879

„Mary Mother"
Ca. 1866
Albuminpapier-Abzug vom
Glas-Negativ
334 x 245 mm

Julia Margaret Cameron
England, 1815-1879

Sir John F. Herschel
1867
Albuminpapier-Abzug vom
Glas-Negativ
330 x 262 mm

Julia Margaret Cameron
England, 1815-1879

"Mary Mother"
1866 ca.
Albumen print from
glass negative
334 x 245 mm

Julia Margaret Cameron
England, 1815-1879

Sir John F. Herschel
1867
Albumen print from
glass negative
330 x 262 mm

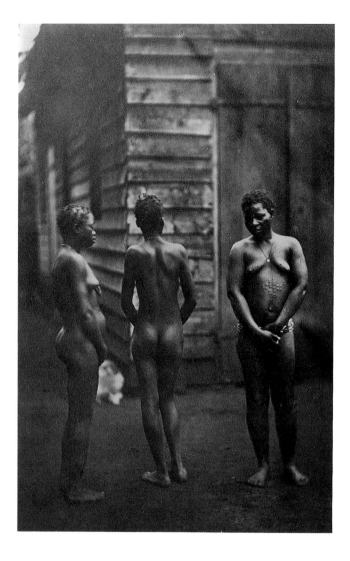

Désiré Charnay
Frankreich, 1828-1915

Drei Frauen, Madagaskar
1863 (Tafel Nr. 30)
Albuminpapier-Abzug vom
nassen Kollodium-Glas-Negativ
200 x 135 mm

Désiré Charnay profilierte sich
mit Photographien über
präkolumbianische Architektur.
Seine Aufnahmen dokumen-
tierten den Zustand der Yucatan-
Monumente vor ihrer Restaurie-
rung. In einem Madagaskar-
Album *Mission de 1863* wandte
sich Charnay einem anderen
Interessengebiet zu: der
Anthropologie.

Désiré Charnay
Frankreich, 1828-1915

„Baobab", Madagaskar
1863
Albuminpapier-Abzug vom
nassen Kollodium-Glas-Negativ
286 x 225 mm

Diese Aufnahme entstand auf
der Insel Mohély; sie wurde
Tafel Nr. 21 des Albums *Mission
de 1863*.

Désiré Charnay
France, 1828-1915

Three Women, Madagascar
1863 (Plate Nr. 30)
Albumen print from
wet-collodion glass negative
200 x 135 mm

Charnay is best known for his
work on pre-Columbian
architecture. His photographs
provide valuable information
on the condition of the Yucatan
Monuments before they
underwent restoration work. In
the Madagascar album *Mission
de 1863,* Charnay turns
his attention to another area
of interest, anthropology.

Désiré Charnay
France, 1828-1915

"Baobab", Madagascar
1863
Albumen print from
wet-collodion glass negative
286 x 225 mm

This photograph was taken
on the island of Mohély, and
is plate Nr. 21 in the *Mission
de 1863* album.

Carleton E. Watkins
Vereinigte Staaten von Amerika,
1825-1916

„Vernal Falls, 350 ft., Yosemite
Valley, California, Nr. 49"
1866
Albuminpapier-Abzug vom
nassen Kollodium-Glas-Negativ
402 x 516 mm

Carleton E. Watkins
Vereinigte Staaten von Amerika,
1825-1916

"Three Brothers, 4000 ft.,
Yosemite Valley, California,
Nr. 42"
1866
Albuminpapier-Abzug vom
nassen Kollodium-Glas-Negativ
402 x 515 mm

Carleton E. Watkins, im Staate
New York geboren, übersiedelte
1851 nach Kalifornien und
erlernte die Photographie bei
Robert Vance. 1861 betrieb er
sein eigenes Atelier, spezialisiert
eher auf Landschafts-
Aufnahmen denn auf die
populärere Portrait-
Photographie. Er arbeitete in
Yosemite, Oregon und im Gebiet

des Columbian River. Seine
prächtigen Landschafts-
Aufnahmen wurden anläßlich
der Pariser Ausstellung von
1867 mit einer Medaille
prämiert.
Das Erdbeben in San Francisco
von 1906 zerstörte sein Atelier.

Carlton E. Watkins
United States, 1825-1916

"Vernal Falls, 350 ft., Yosemite
Valley, California, Nr. 49"
1866
Albumen print from wet-
collodion glass negative
402 x 516 mm

Carleton E. Watkins
United States, 1825-1916

"Three Brothers, 4000 ft.,
Yosemite Valley, California,
Nr. 42"
1866
Albumen print from
wet-collodion glass negative
402 x 515 mm

Carleton E. Watkins, born in New
York State, moved to California
in 1851 where he studied
photography under Robert
Vance. By 1861, he had his own
studio, concentrating on
landscapes rather than on the
more popular portraiture. He
worked in Yosemite, Oregon,
and in the Columbian river
region. His magnificent

landscapes were exhibited at
the Paris Exposition of 1867
where they won a medal. In
1906, the San Francisco
earthquake destroyed his
studio.

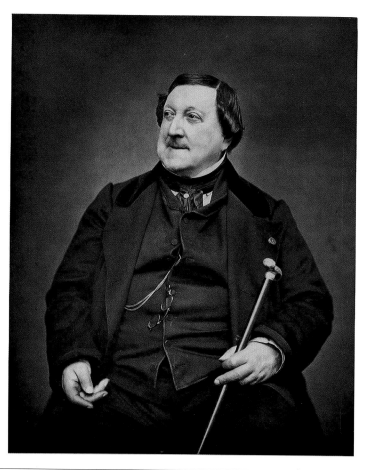

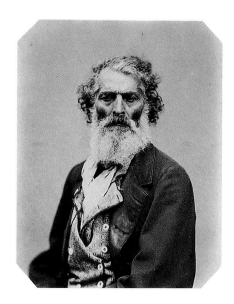

Etienne Carjat
Frankreich, 1828-1906

Gioacchino Rossini (1792-1868)
1862
Woodburytypie vom nassen
Kollodium-Glas-Negativ
240 x 190 mm

Die abgebildete Aufnahme
Rossinis ist Teil der Serie
Galerie Contemporaine,
welche in 241 Portraits
berühmter Zeitgenossen ein
Panorama des „Second
Empire" und der Dritten
Republik zeichnete. Goupil
publizierte diese Buchreihe in
Paris 1877.

Philippe Potteau
Frankreich

„Jean Lagrène"
1865
Albuminpapier-Abzug vom
Glas-Negativ
150 x 130 mm

Das Modell für Edouard Manets
Gemälde „Der Alte Musiker"
(1862) wurde aufgrund der
abgebildeten Photographie
identifiziert: Jean Lagrène, ein
Zigeuner, der beruflich Malern
Modell stand. Die Aufnahme
entstand als Teil einer Portrait-
serie ethnischer Gruppen, die
er auftrags des Pariser Musée
d'Histoire Naturelle schuf.

Etienne Carjat
France, 1828-1906

Gioacchino Rossini (1792-1868)
1862
Woodburytype from
wet-collodion glass negative
240 x 190 mm

Etienne Carjat opened a studio
in 1861 in Paris, and the same
year founded the periodical, *Le
Boulevard.* This photograph is
included in the book *Galerie
Contemporaine,* a series of 241
portraits of celebrated persona-
lities in France during the
Second Empire and Third
French Republic. *This series*
was published in Paris by
Goupil in 1877.

Philippe Potteau
France

"Jean Lagrène"
1865
Albumen print
from glass negative
150 x 130 mm

The model for Edouard Manet's
painting "The Old Musician"
(1862) has been identified on
the basis of this photograph:
Jean Lagrène, agypsy, was a
model for painters. This photo-
graph is one in a series of
portraits of various ethnic
groups taken by Potteau in
Paris for the Musée d'Histoire
Naturelle.

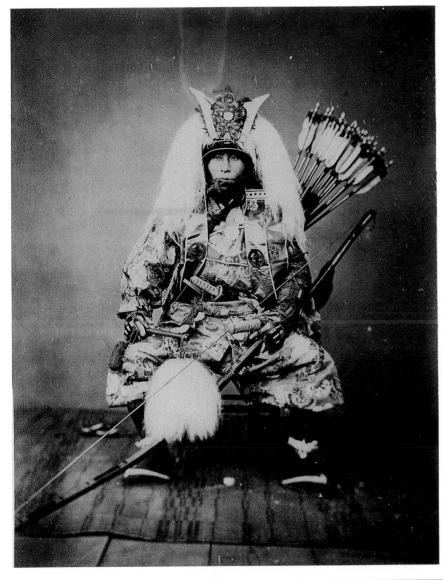

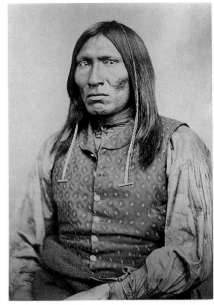

Hikoma Ueno
Japan, 1838-1904

Junger Samurai, Nagasaki
Ca. 1868
Albuminpapier-Abzug vom
nassen Kollodium-Glas-Negativ
131 x 103 mm

Hikomo Ueno war in Japan
zwischen den 60er und 90er
Jahren des 19. Jahrhunderts
als kommerzieller Photograph
tätig. Mit Kusakabe und viel-
leicht ein, zwei weiteren
Photographen kann man
Hikoma eine der dominanten
Persönlichkeiten seines Fachs
im Japan des 19. Jahrhunderts
nennen.

Will Soule
Vereinigte Staaten von Amerika,
1836-1908

*Ho Wear, Häuptling der
Yapparika-Komanchen*
Ca. 1870
Albuminpapier-Abzug vom
Glas-Negativ
137 x 95 mm

Als sein Atelier in Pennsylvania
1867 niederbrannte, kaufte Will
Soule eine neue Photoaus-
rüstung und zog nach Saint
Louis, wo er im Laden des Fort
Dodge arbeitete. Später wurde
er Lager-Photograph im Fort
Sill. Er sandte seine
Photographien seinem Bruder,
der ihren Verkauf organisierte.

Hikoma Ueno
Japan, 1838-1904

Young Samurai, Nagasaki
1868 ca.
Albumen print from
wet-collodion glass negative
131 x 103 mm

Hikoma Ueno worked as a
commercial photographer in
Japan from the 1860's to the
1890's. With Kusakabe and
perhaps one or two others, he
was a major figure in nineteenth
century Japanese photography.

Will Soule
United States, 1836-1908

*Ho Wear, The Yapparika-
Comanche Chief*
1870 ca.
Albumen print from
glass negative
137 x 95 mm

When his studio in Pennsylvania
burned in 1867, Will Soule
bought himself some new
photographic equipment and
headed for Saint Louis where
he took a job in the camp store
at Fort Dodge. Later, he became
camp photographer at Fort Sill
and sent his work to his brother,
who managed to sell the
photographs.

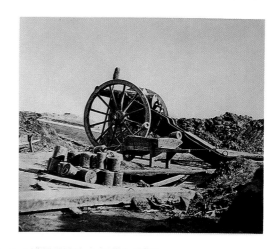

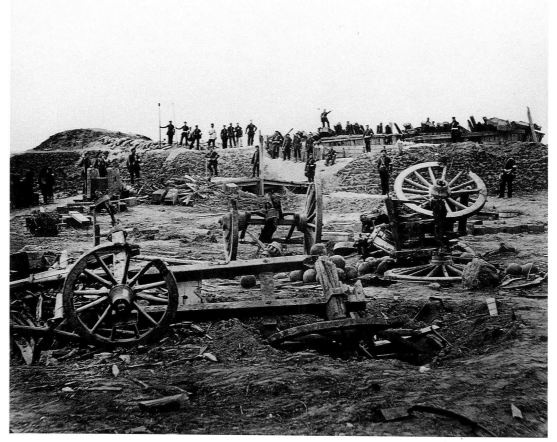

90

Friedrich Brandt
Deutschland, 1823-1891

*Deutsch-Dänischer Krieg:
Düppeler Schanzen*
1864
Albuminpapier-Abzug vom
nassen Kollodium-Glas-Negativ
171 x 416 mm

Friedrich Brandt
Deutschland, 1823-1891

*Von den preußischen Truppen
erbeutete dänische Kanone*
1864
Albuminpapier-Abzug vom
nassen Kollodium-Glas-Negativ
174 x 210 mm

Friedrich Brandt und seine
Kollegen erhielten eine
Genehmigung für das
Photographieren erst, nachdem
die 6000 Toten und
Verwundeten nicht mehr auf
dem Schlachtfeld zu sehen
waren.

Friedrich Brandt
Germany, 1823-1891

*German-Danish War:
Düppler Trenches*
1864
Albumen print from
wet-collodion glass negative
171 x 416 mm

Friedrich Brandt
Germany, 1823-1891

*Danish Cannon Captured by
Prussian Troops*
1864
Albumen print from wet-
collodion glass negative
174 x 210 mm

Brandt and his colleages were
only permitted to start
photographing after the 6,000
dead and wounded had been
cleared from the scene
of the battle by Prussian troops.

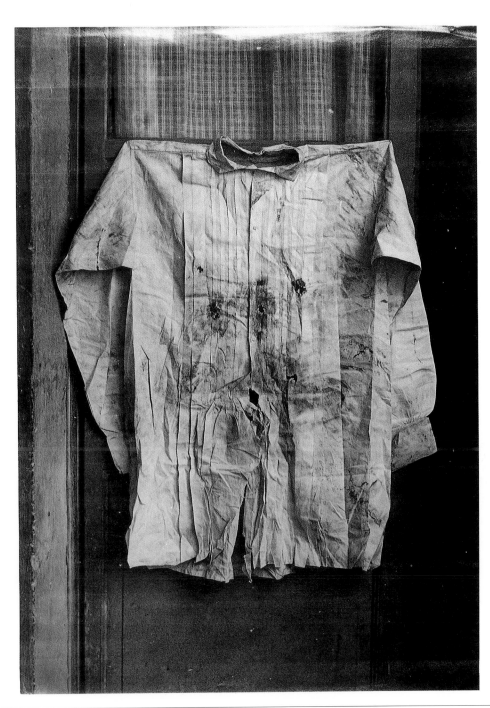

François Aubert
Frankreich

*Kaiser Maximilians Hemd nach
seiner Erschießung*
1867
Albuminpapier-Abzug vom
nassen Kollodium-Glas-Negativ
218 x 157 mm

Der österreichische Erzherzog
Maximilian und zwei seiner
Generäle wurden von einem
Kommando republikanischer
Truppen am 19. Juni 1867 in der
mexikanischen Stadt Querétaro
exekutiert. Von Napoleon III. zu
diesem Wagnis überredet,
hatte Maximilian drei Jahre
lang Mexico regiert. Edouard
Manet benutzte mehrere

Photographien Auberts als
Vorlage für eines seiner bekann-
testen Gemälde: „Die
Erschießung Kaiser
Maximilians".

François Aubert
France

*The Emperor Maximilian's Shirt
after his Execution*
1867
Albumen print from
wet-collodion glass negative
218 x 157 mm

The Austrian archduke
Maximilian and two of his
generals were executed before
a firing squad of Republican
troops on June 19, 1867 in the
Mexican city of Querétaro.
Maximilian ruled Mexico for
three years, having been
persuaded by France's
Napoleon III to undertake this
venture. Edouard Manet used

several of François Aubert's
photographs for one of his best
known paintings, "The Shooting
of the Emperor Maximilian".

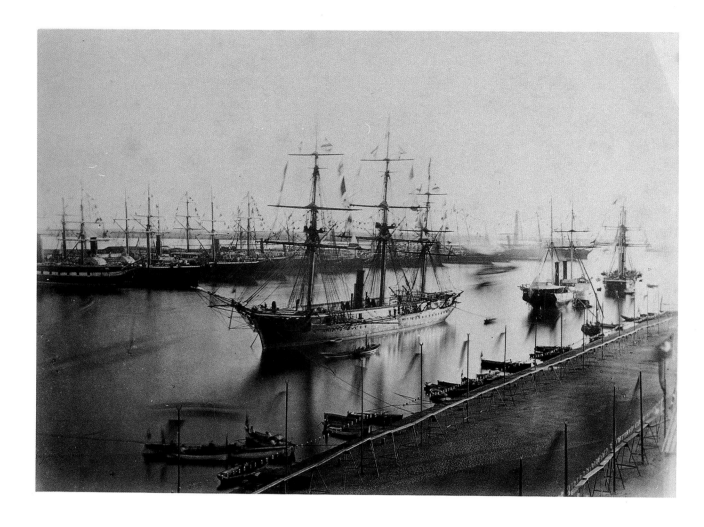

Justin Kozlowski
Polen/Frankreich

*Port Said am Eröffnungstag
des Suez-Kanals*
16. November 1869
Albuminpapier-Abzug vom
nassen Kollodium-Glas-Negativ
190 x 278 mm

Justin Kozlowskis biographische
Daten sind nahezu unbekannt,
seine Nationalität kann polnisch
oder französisch sein. Er
photographierte den Suez-
Kanal, der zwischen 1859 und
1869 gebaut wurde, in
verschiedenen Etappen
während des Baues und von
verschiedenen Standpunkten
aus. Zur Zeit dieser Aufnahme

maß der Kanal 22 Meter in der
Breite und 8 Meter in der Tiefe
– heute ist er 120 Meter breit
und 16 Meter tief.

Justin Kozlowski
Poland/France

*Port Said on the Day
of Suez Canal's Opening*
November 16, 1869
Albumen print from
wet-collodion glass negative
190 x 278 mm

Very little is known of Kozlowski,
who is thought to be either
French or Polish. He
photographed the Suez Canal,
built between 1859-1869, at
various stages of its construction
and from different view points.
In those days, the canal measured
22 metres in width and was
8 metres deep. Today it is 120
metres wide and 16 metres deep.

Carlo Ponti
Italien, 1821-1893

Segelboot in Venedig
Ca. 1856
Salzpapier-Abzug vom
Glas-Negativ
213 x 270 mm

Der gelernte Optiker Carlo Ponti war einer der prominentesten Photographen Italiens. Ab 1860 begann Ponti, seine Aufnahmen von Venedig als Alben gebunden und mit *Ricordo di Venezia* betitelt zu verkaufen. Der Käufer konnte aus einer Serie zwanzig Aufnahmen auswählen, die dann gebunden wurden. Jedes Bild wurde von einem das Sujet erklärenden Text begleitet, mit Angaben über Details der Ansicht und kurzen historischen Hinweisen in italienischer, französischer und englischer Sprache.
1866 erhielt Ponti in Venedig den Titel eines Optikers und Photographen des Königs von Italien.

Carlo Ponti
Italy, 1821-1893

A Sailing Boat in Venice
1856 ca.
Salz print from glass negative
213 x 270 mm

Carlo Ponti, an optician, was one of Italy's most prominent photographers. Beginning in the 1860's, Ponti began selling his pictures of Venice in albums entitled *Ricordo di Venezia.* Judging by the variety of prints found in extant examples, the purchaser must have selected twenty photographs to be bound with an inexpensive embossed cover. Each photograph would be accompanied with a verso describing the location of the view and a short history in Italian, French and English. In Venice in 1866, Ponti was awarded the titel, Optician and Photographer to H.M. the King of Italy.

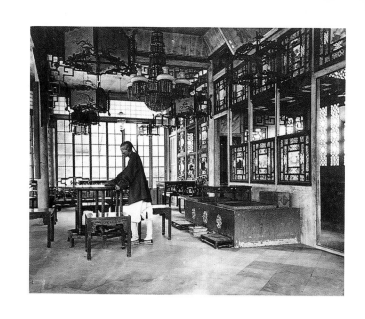

John Thomson
Schottland, 1837-1921

Der Tempel der fünfhundert Götter, Kanton, China
1869
Albuminpapier-Abzug vom nassen Kollodium-Glas-Negativ
240 x 277 mm

John Thomson
Schottland, 1837-1921

Pun-ting-Qua's Theater, Kanton, China
1869
Albuminpapier-Abzug vom nassen Kollodium-Glas-Negativ
227 x 277 mm

John Thomson
Schottland, 1837-1921

Zwei Jungen in Singapur
1864
Albuminpapier-Abzug vom nassen Kollodium-Glas-Negativ
172 x 234 mm

1865 verließ John Thomson England und verbrachte zehn Jahre in Asien. Vier Bände, das Resultat seiner Reise, wurden unter dem Titel *Illustrations of China and Its People* in London 1874 von Sampson Low, Marston, Low & Searle publiziert.

John Thomson
Scotland, 1837-1921

The Temple of the Five-Hundred Gods, Canton, China
1869
Albumen print from wet-collodion glass negative
240 x 277 mm

John Thomson
Scotland, 1837-1921

Pun-ting-Qua's Theater, Canton, China
1869
Albumen print from wet-collodion glass negative
227 x 277 mm

John Thomson
Scotland, 1837-1921

Two Boys in Singapore
1864
Albumen print from wet-collodion glass negative
172 x 234 mm

In 1865, John Thomson left England and spent the following ten years in Asia. The four volume publication which was the result of this trip was published under the title, *Illustrations of China and Its People* (London: Sampson Low, Marston, Low & Searle, 1873-1874).

Roger Fenton
England, 1819-1869

*Das Schießen um den Preis
des Herzogs von Cambridge,
Wimbledon*
Juli 1860
Albuminpapier-Abzug vom
nassen Kollodium-Glas-Negativ
227 x 280 mm

Am 2. Juli 1860 wurde in
Wimbledon das jährliche
Preis-Schießen der National
Rifle Association in Anwesen-
heit der königlichen Familie
unter dem Patronat des Herzogs
von Cambridge, dem Komman-
danten der Britischen Armee,
eröffnet. Eine Eintragung in
Königin Victorias Tagebuch ruft
das Ereignis in Erinnerung:

„Wir gelangten durch den
Wimbledon-Park zum
Veranstaltungsort, wo eine
große Menschenmenge
versammelt war. George (der
Herzog von Cambridge) und das
Komitee empfingen uns am
Eingang eines schönen großen
Zeltes..., darauf gelangten wir
in ein anderes, kleines Zelt, wo
ein Gewehr von Mr. Whitworth

persönlich eingerichtet worden
war. Ich zog leicht an einer
Schnur und es ging los, das
Geschoß erreichte das Ziel auf
300 Yards (Ca. 275 Meter). Lord
Elcho überreichte mir die
Medaille. Dann kehrten wir in
das große Zelt zurück, wo wir
einige Zeit verweilten, die
Bands spielten auf und das
Preis-Schießen begann."

Roger Fenton
England, 1819-1869

*„A Shooting for the Duke
of Cambridge's Prize,"
Wimbledon*
July, 1860
Albumen print from
wet-collodion glass negative
227 x 280 mm

On July 2, 1860, the annual
shooting competition of the
"National Rifle Association" was
held in Wimbledon in the
presence of the Royal Family
under the patronage of
the Duke of Cambridge, the
Commader-in-Chief of the
British Army. An entry in Queen
Victoria's diary reads:
"We went... through

Wimbledon Park to the
Common where there was an
immense concourse of people.
George (The Duke of
Cambridge) with the Committee
received us at the entrance of a
fine large tent... afterwards
walked up the line to another
small tent, where the rifle was
fixed by Mr. Whitworth himself.
I gently pulled a string and it

went off, the bullet entering the
bull's eye at 300 yards.
Ld. Elcho gave me the medal.
We then returned to the big
tent, remaining there some
time, the bands playing, while
the shooting began".

 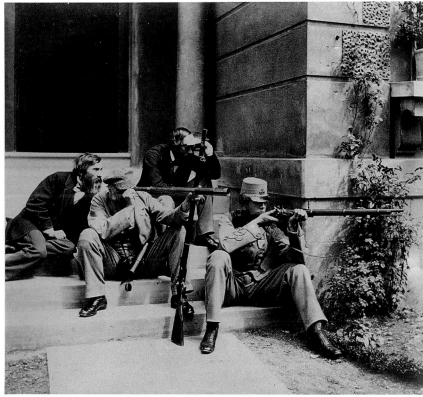

Roger Fenton
England, 1819-1869

Edward Ross: Gewinner des
königlichen Preises
Juli 1860
Albuminpapier-Abzug vom
nassen Kollodium-Glas-Negativ
275 x 246 mm

Roger Fenton
England, 1819-1869

Horatio Ross
und der Sieger Edward Ross
Juli 1860
Albuminpapier-Abzug vom
nassen Kollodium-Glas-Negativ
253 x 276 mm

Der Vize-Präsident der
Schottischen Gesellschaft der
Photographie, Horatio Ross,
selbst ein begabter Photograph,
hatte das Preis-Schießen von
Wimbledon jahrelang
gewonnen; 1860 gewann
erstmals sein Sohn Edward.

Roger Fenton
England, 1819-1869

„*E. Ross: Winner of the*
Queen's Prize"
July, 1860
Albumen print from wet-
collodion glass negative
275 x 246 mm

Roger Fenton
England, 1819-1869

Horatio Ross and the Winner
Edward Ross
July, 1860
Albumen print from
wet-collodion glass negative
253 x 276 mm

Vice-President of the Scottish
Society of Photography and
himself a talented
photographer, Horatio Ross
had been a consistant winner
of the shooting competition
in Wimbledon. This time, and
for the first time, it was his son
who took the honours.

98

Roger Fenton
England, 1819-1869

*Das Whitworth-Gewehr,
das die Königin benutzte*
Juli 1860
Albuminpapier-Abzug vom
nassen Kollodium-Glas-Negativ
264 x 288 mm

Der Büchsenmacher Whitworth
war persönlich für die
Einrichtung des Gewehres in
Richtung der „königlichen"
Schießscheibe verantwortlich.
Bei aufmerksamer Betrachtung
ist die Schnur, an der Königin
Victoria „leicht" zog, gut zu
sehen.

Roger Fenton
England, 1819-1869

„The Queen's Target"
Juli 1860
Albuminpapier-Abzug vom
nassen Kollodium-Glas-Negativ
212 x 212 mm

Das Resultat des königlichen
Schusses: Die modernste
Photographie des 19. Jahr-
hunderts!

Roger Fenton
England, 1819-1869

*"The Whitworth Rifle
Fired by the Queen"*
July, 1860
Albumen print from
wet-collodion glass negative
264 x 288 mm

The gunsmith, Mr. Whitworth
was personally responsible
for setting up the rifle directed
at the Queen's Target. Keen
observation of this photograph
will reveal the line, attached
to the trigger, which the Queen
pulled.

Roger Fenton
England, 1819-1869

"The Queen's Target"
July, 1860
Albumen print from
wet-collodion glass negative
212 x 212 mm

The result of the Queen's shot:
the most modern photograph
of the nineteenth century!

Francis Bedford
England, 1816-1894

Kalifen-Gräber, Kairo
25. März 1862
Albuminpapier-Abzug vom
nassen Kollodium-Glas-Negativ
229 x 284 mm

Francis Bedford, Maler und
Lithograph, begleitete 1862
den Prinzen von Wales auf
einer Reise in den Nahen
Osten. *The Art Journal* nannte
Bedfords Aufnahmen dieser
Reise „die interessantesten je
publizierten Photographien",
nichts „könne schöner sein, als
die Präzision dieser
Aufnahmen".

Francis Bedford
England, 1816-1894

Caliph Graves, Cairo
March 25, 1862
Albumen print from
wet-collodion glass negative
229 x 284 mm

Francis Bedford, a painter and
lithographer, accompanied the
Prince of Wales on a tour of the
Near East in 1862. *The Art
Journal* called Bedford's work
from the tour, "the most
interesting series of photographs
that has ever been brought
before the public... Nothing can
be more beautiful than the
precision of these photographs".

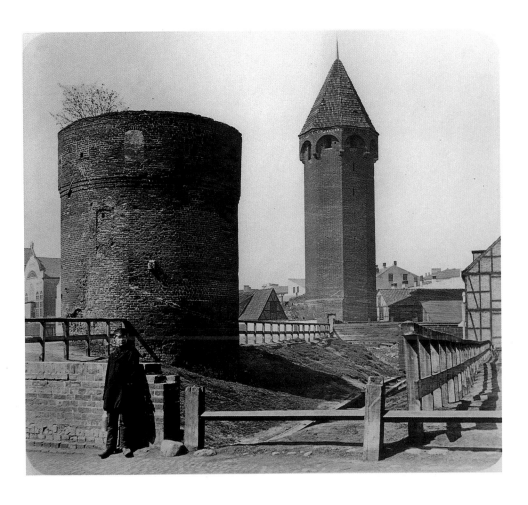

A. Ballerstaedt
Deutschland

Der Turm „Kiek in de Kök",
Danzig
Ca. 1865
Albuminpapier-Abzug vom
nassen Kollodium-Glas-Negativ
190 x 200 mm

A. Ballerstaedt
Germany

The Tower, "Kiek in de Kök",
Danzig
1865 ca.
Albumen print from
wet collodion glass negative
190 x 200 mm

102 **Carl Friedrich Mylius**
 Deutschland, 1827-1916

 Der Alte Brunnen in der
 Stiftstraße, Frankfurt
 1866
 Albuminpapier-Abzug vom
 nassen Kollodium-Glas-Negativ
 232 x 167 mm

Carl Friedrich Mylius eröffnete
1854 in Frankfurt ein Atelier. Er
wurde als Portrait-Photograph
und als Photograph von Städte-
ansichten sehr erfolgreich.
Der Alte Brunnen wurde 1866
abgerissen, als die Stiftstraße
verbreitert wurde.

 Carl Friedrich Mylius
 Germany, 1827-1916

 The Old Well in Stiftstrasse,
 Frankfurt
 1866
 Albumen print from
 wet-collodion glass negative
 232 x 167 mm

Carl Friedrich Mylius opened his
studio in Frankfurt in 1854 and
was a successful commercial
photographer of portraits and
city sights.

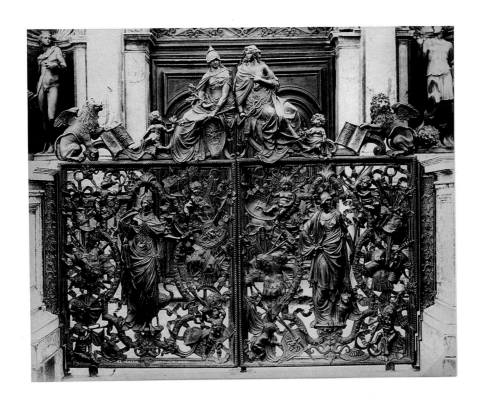

Carlo Naya
Italien, 1816-1882

*Bronze-Tor, Eingang zum
Campanile, Venedig*
Ca. 1865
Albuminpapier-Abzug vom
nassen Kollodium-Glas-Negativ
412 x 535 mm

Nicht nur in Italien, sondern in
ganz Europa fand Carlo Naya
Anerkennung: seine
photographischen Arbeiten
erhielten außerordentlich oft
Auszeichnungen bei
Ausstellungen.

Carlo Naya
Italy, 1816-1882

*Bronze Gate, Entrance
to Campanile, Venice*
1865 ca.
Albumen print from
wet-collodion glass negative
412 x 535 mm

Naya was an admired
photographer not only in Italy,
but throughout Europe.
He, and later his studio,
received an extraordinary
amount of recognition at
expositions.

Auguste-Rosalie Bisson
Frankreich, 1826-1900

Ersteigung des Mont-Blanc
1861
Albuminpapier-Abzug vom
nassen Kollodium-Glas-Negativ
240 x 400 mm

Auguste-Rosalie Bisson
Frankreich, 1826-1900

*„La Crevasse", Ersteigung des
Mont-Blanc*
1861
Albuminpapier-Abzug vom
nassen Kollodium-Glas-Negativ
400 x 240 mm

Auguste-Rosalie Bisson
France, 1826-1900

Ascent of Mont-Blanc
1861
Albumen print from
wet-collodion glass negative
240 x 400 mm

Auguste-Rosalie Bisson
France, 1826-1900

*"La Crevasse",
Ascent of Mont-Blanc*
1861
Albumen print from wet-
collodion glass negative
400 x 240 mm

106 **Lewis Morris Rutherfurd**
Vereinigte Staaten von Amerika,
1816-1892

Photographie des Mondes
6. März 1865
Albuminpapier-Vergrößerung
vom nassen Kollodium-Glas-
Negativ
397 x 303 mm

Der New Yorker Astronom
Lewis Morris Rutherfurd war
mit einer der ersten, die den
Himmel photographierten.
1864 konstruierte er das erste,
für die Photographie
uneingeschränkt taugliche
Teleskop. Rutherfurd hielt
wissenschaftliche Vorträge, so
1866 vor der Wiener Akademie
zum konkreten Problem der

Mond-Photographie und zum
Sonnen-Spektrum.

Lewis Morris Rutherfurd
United States, 1816-1892

Photograph of the Moon
March 6, 1865
Albumen enlargement from
wet-collodion glass negative
397 x 303 mm

The Astronomer from New York
Lewis Morris Rutherfurd was
among the first to photograph
the sky. In 1864, he constructed
the first telescope (11 1/4
inches aperture) corrected for
photographic rays and made
the finest diffraction gratings
obtainable prior to those of
Rowland. In 1866, he delivered
a lecture to the Vienna Academy

on the photography of the
moon and of the solar spec-
trum.

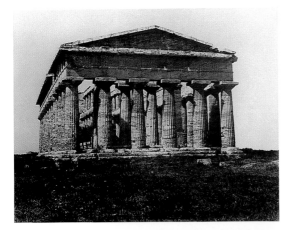

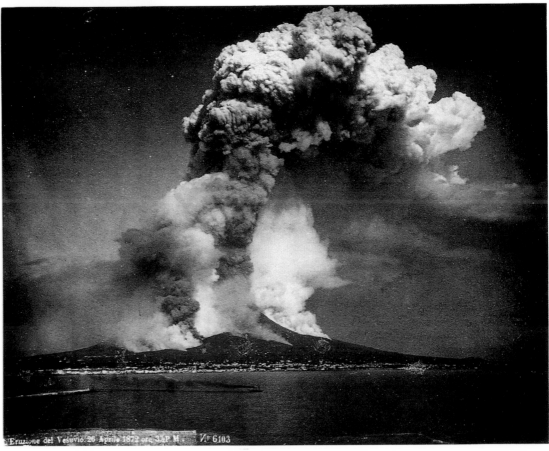

Roberto Rive
Italien

*Der Tempel des Poseidon
in Paestum*
Ca. 1865
Albuminpapier-Abzug vom
nassen Kollodium-Glas-Negativ
288 x 373 mm

Giorgio Sommer
Deutschland/Italien, 1834-1914

Ausbruch des Vesuv
26. April 1872
Albuminpapier-Abzug vom
Glas-Negativ
183 x 243 mm

Der gebürtige Frankfurter
Georg Sommer erlernte in der
Schweiz die Photographie,
bevor er in Neapel ein Atelier
eröffnete. Wie die meisten
Photographen verdiente auch
Sommer anfänglich den
Lebensunterhalt mit der
Portrait-Photographie, doch
sein Schwergewicht verlagerte
sich bald auf Städteansichten,

Straßenszenen und Aufnahmen
berühmter Kunstwerke. Bis
heute ist er vor allem durch
seine Landschaftsaufnahmen
bekannt.

Roberto Rive
Italy

Paestum: Temple of Poseidon
1865 ca.
Albumen print from
wet-collodion glass negative
288 x 373 mm

Giorgio Sommer
Germany/Italy, 1834-1914

Eruption of Mt. Vesuvius
April 26, 1872
Albumen print from
glass negative
183 x 243 mm

A native of Frankfurt, Sommer
studied photography in
Switzerland and by 1857 had
opened a studio of his own
in Naples. Like most
photographers initially he
depended on portraiture for a
living but later took up
topographical views and art
reproductions as his
specialities.

Today he is best known for
his landscapes.

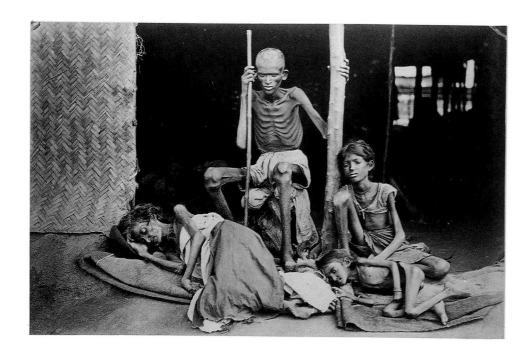

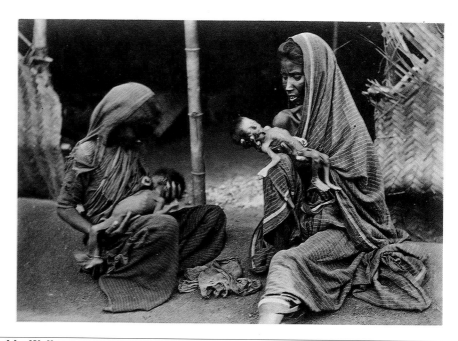

Willoughby Wallace Hooper
England, 1837-1912

„Waiting for Help", Indien
1878
Albuminpapier-Abzug
vom Glas-Negativ
101 x 155 mm

Willoughby Wallace Hooper
England, 1837-1912

„Starving Children: Aged
three, weight three pounds",
Indien
1878
Albuminpapier-Abzug vom
Glas-Negativ
101 x 153 mm

Willoughby Wallace Hooper
England, 1837-1912

"Waiting for Help", India
1878
Albumen print from glass
negative
101 x 155 mm

Willoughby Wallace Hooper
England, 1837-1912

"Starving Children: Aged three,
weight three pounds", India
1878
Albumen print from glass
negative
101 x 153 mm

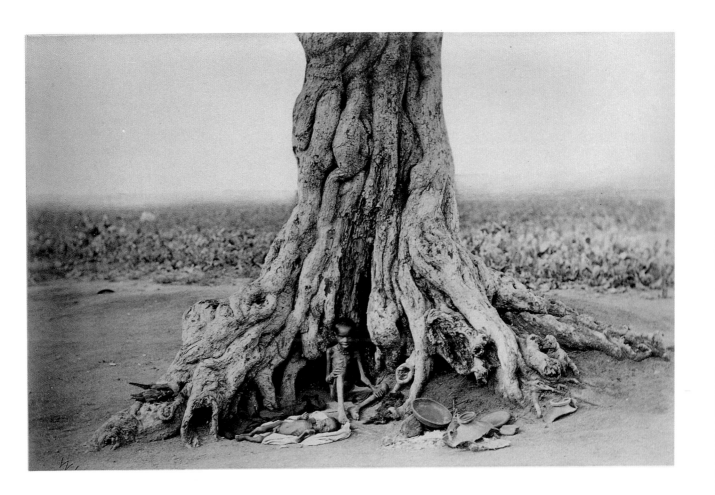

Willoughby Wallace Hooper
England, 1837-1912

Junge und Baby, Indien
1878
Albuminpapier-Abzug vom
Glas-Negativ
101 x 153 mm

Willoughby Wallace Hooper, in
Surrey geboren, diente in der
Madras Light Cavalry zwischen
1858 und 1896. Naomi Rosen-
blum beschrieb Hoopers Arbeit
1984: „Die Photographien der
Hindus niederer Kasten des
britischen Captains der Armee
W. W. Hooper sind weitere
Hinweise auf ein verstärktes
Interesse des Westens an

den sozialen Problemen
benachteiligter Gruppen
überall in der Welt."

Willoughby Wallace Hooper
England, 1837-1912

Boy and Baby, India
1878
Albumen print from glass
negative
101 x 153 mm

W.W. Hooper, born in Surrey,
served in the Madras Light
Cavalry between 1858-1896.
Namoni Rosenblum wrote of
his work in 1984, "Photographs
of lower-caste Hindus taken
by British Army Captain
W.W. Hooper are further
indication of the growing
interest among westerners
in the social problems of

the lower classes around the
world".

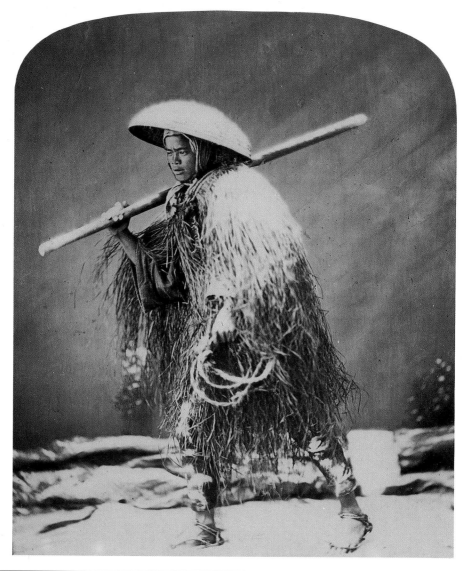

**Raimund Stillfried
von Rathenitz**
Österreich, 1839-1911

Kuli in Winterkleidern
Ca. 1875
Kolorierter Albuminpapier-Abzug
vom nassen Kollodium-Glas-
Negativ
227 x 170 mm

Bevor seine Karriere als
Photograph begann, diente
Raimund Stillfried von Rathenitz
als Offizier der österreichischen
Armee und arbeitete als Maler.
Schließlich ließ er sich in Japan
nieder, eröffnete ein
photographisches Atelier in
Yokohama, erst unter der Firma
„Stillfried & Comp.", dann
unter derjenigen von „Stillfried

& Anderson". Im Laufe seiner
Karriere in Japan wurde er
Vorsitzender der Japanischen
Vereinigung der Photographie
und Vorsitzender des Aufsichts-
rates der Druckereibetriebe der
Stadt Tokyo. Daneben arbeitete
er als Hochschullehrer.

**Raimund Stillfried
von Rathenitz**
Austria, 1839-1911

Coolie in Winter Dress
1875 ca.
Coloured albumen print from
wet-collodion glass negative
227 x 170 mm

Before beginning his career as
a photographer, Stillfried von
Rathenitz served as an officer in
the Austrian army and worked
as a painter. Eventually, he
settled in Japan where he set
up a studio in Yokohama under
the name "Stillfried & Comp."
and later "Stillfried & Anderson".
During his career in Japan, he
became the chairman of the

Japan Photographic
Association, was appointed
Chairman of the Board of the
City of Tokyo Printing Office,
and worked as a college
instructor.

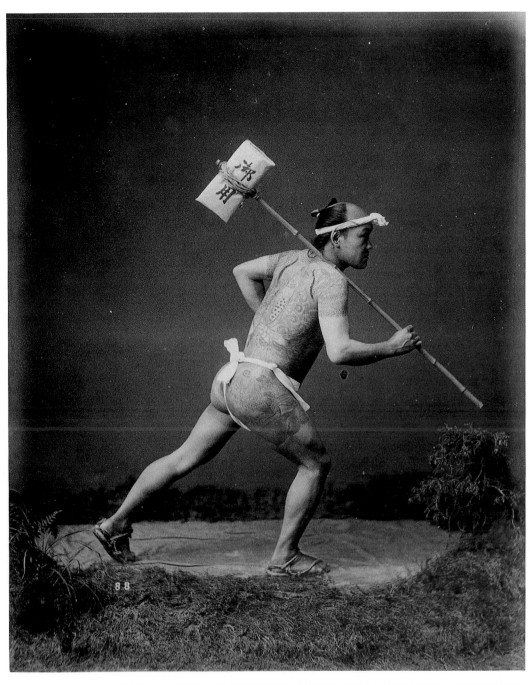

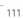

Kimbei Kusakabe
Japan, 1880-1912

Post-Kurier, Japan
Ca. 1885
Kolorierter Albuminpapier-
Abzug vom Glas-Negativ
256 x 203 mm

Kimbei Kusakabe war *der*
kommerzielle Photograph im
Japan des 19. Jahrhunderts.
Beato, Stillfried von Rathenitz
und Kusakabes Arbeiten
komplementieren ein Bild ihrer
Epoche in Japan. Kusakabe
begann vermutlich als Assistent
Stillfried von Rathenitz' und
erwarb dessen Ausrüstung, als
dieser Mitte der 80er Jahre das

Land verließ. Kusakabe betrieb
bis 1912 sein eigenes Atelier.

Kimbei Kusakabe
Japan, 1880-1912

"Postrunner", Japan
1885 ca.
Coloured albumen print
from glass negative
256 x 203 mm

Kimbei Kusakabe was the great
Japanese commercial
photographer of the 19th
century. There is a direct link
between the work of Beato,
Stillfried von Rathenitz and
Kusakabe, in that it represents a
cross-cultural view of Japan
during the period.
It is also probable that Kusakabe
began as Stillfried von

Rathenitz's operator, eventually
buying his equipment when the
later departed from Japan in
the mid-1880's. He ran his own
firm until 1912 when he
disappeared from view.
Kusakabe was particularly noted
for studio portraits.

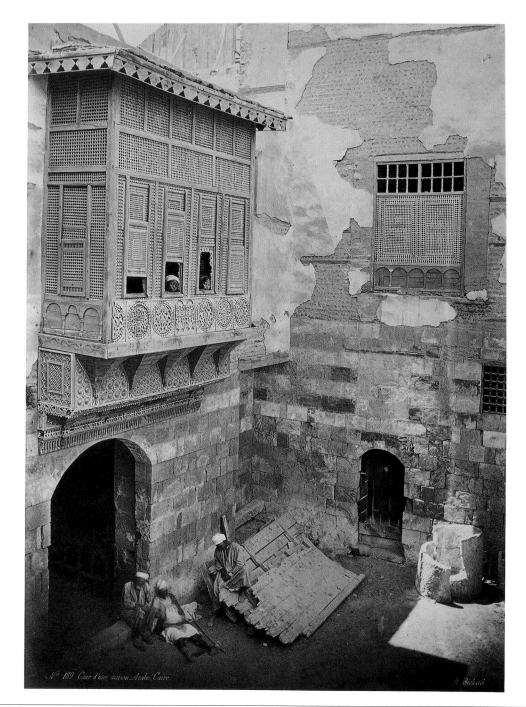

N° 189. Cour d'une maison Arabe. Cairo. H. Béchard

112 **Henri Béchard**
Frankreich

*Innenhof eines arabischen
Hauses, Kairo*
Ca. 1875
Albuminpapier-Abzug vom
Glas-Negativ
370 x 267 mm

Henri Béchard arbeitete in den
70er und 80er Jahren in
Ägypten. Seine Photographien
wurden als Photogravuren in
einem Album unter dem Titel
L'Egypte et Nubie 1887 von
André Palmiere und Emile
Béchard in Paris herausgegeben.

Henri Béchard
France

*Court Yard of Arab House,
Cairo*
1875 ca.
Albumen print from
glass negative
370 x 267 mm

Henri Béchard worked in Egypt
in the 1870's and 1880's.
His photographs were
published as photogravures in
L'Egypte et Nubie, edited in
1887 by André Palmiere and
Émile Béchard in Paris.

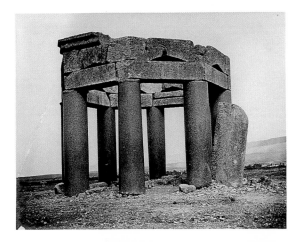

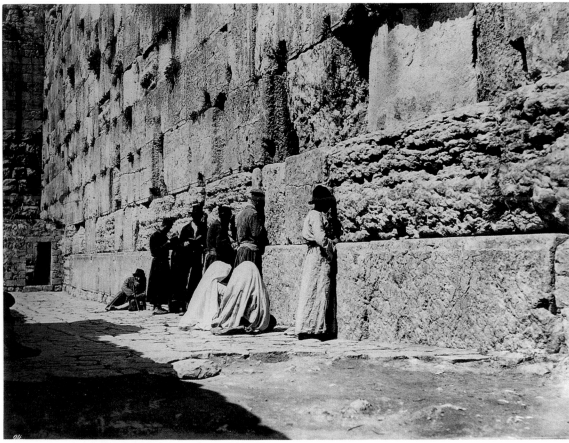

Félix Bonfils Frankreich, 1831-1885 „Coupole de Douris", Baalbek Ca. 1870 Albuminpapier-Abzug vom Glas-Negativ 290 x 385 mm	**Félix Bonfils** Frankreich, 1831-1885 Klagemauer in Jerusalem Ca. 1870 Albuminpapier-Abzug vom Glas-Negativ 275 x 380 mm	Félix Bonfils zog 1867 mit seiner Familie von Frankreich in den Libanon. Er galt als einer der ersten und produktivsten Photographen des Mittleren Ostens.
Félix Bonfils France, 1831-1885 "Coupole de Douris", Baalbek 1870 ca. Albumen print from glass negative 290 x 385 mm	**Félix Bonfils** France, 1831-1885 Wailing Wall in Jerusalem 1870 ca. Albumen print from glass negative 275 x 380 mm	Félix Bonfils moved his family from France to Lebanon in 1867. He became known as one of the finest and most prolific photographers in the Middle East.

114 **Anonym**

Der Stadtteil Pekings, in dem die ausländischen Botschaften zerstört worden waren
1900
Gelatin-Abzug vom Glas-Negativ
128 x 174 mm

Eine militante Gruppe von Chinesen besetzte und zerstörte im Juni 1900 die Gesandtschaften der Westmächte in Peking, um deren Macht in China zu stoppen; das Ereignis ging unter dem Titel „Der Boxer-Aufstand" in die Geschichte ein. Ein internationales Korps westeuropäischer Truppen besetzte

daraufhin im August 1900 die Stadt. Die abgebildete Photographie, aus einem französischen Militär-Ballon aufgenommen, entstand am Tag der Besetzung.

Anonymous

Peking District with Destroyed Foreign Embassies
1900
Gelatin print from glass negative
128 x 174 mm

In June of 1900, a militant group of Chinese called the "Boxer Movement" occupied and destroyed the foreign embassies in Peking in an attempt to defend China against the invading western powers. An international corps of West European troops took control of the city in August, 1900. This photograph was taken by allied

troops from a French military balloon on the day the city fell.

Franck (François-Marie-Louis-
Alexandre Gobinet de Villecholle)
Frankreich, 1816-1906

Place Vendôme, Paris
16. Mai 1871
Albuminpapier-Abzug vom
nassen Kollodium-Glas-Negativ
192 x 254 mm

Franck begann 1845 zu
photographieren. Während
seines selbstgewählten Exils in
Barcelona zwischen 1849 bis
1857 intensivierte er sein
Studium. Als er nach Paris
zurückkehrte, betrieb er alsbald
ein erfolgreiches Atelier und
wurde Professor für
Photographie an der Ecole
Polytechnique.

Franck (François-Marie-Louis
Alexandre Gobinet de Villecholle)
France, 1816-1906

Place Vendôme, Paris
May 16, 1871
Albumen print from
wet-collodion glass negative
192 x 254 mm

Franck took up photography
around 1845, cultivating this
interest during a self-imposed
exile in Barcelona from 1849-
1857. Upon his return to Paris,
he set up a successful studio,
and became a professor
of photography at the Ecole
Polytechnique.

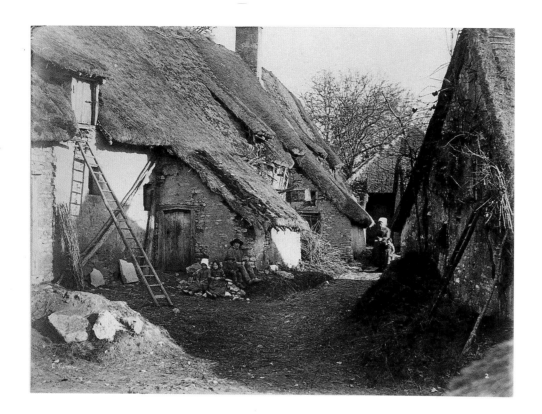

Charles Famin
Frankreich

Dorf im Wald von Fontainebleau
Ca. 1870
Albuminpapier-Abzug vom
Glas-Negativ
257 x 189 mm

Françoise Heilbrun, Kuratorin
am Musée d'Orsay in Paris,
beschrieb Charles Famin 1986
als „bemerkenswertesten
Landschafts-Photographen
seiner Zeit". Sein Werk,
entstanden zwischen dem
Ende der 60er und Mitte der
80er Jahre, beschreibt im
wesentlichen die Gegend um
Fontainebleau. Der Zeitgenosse

der Impressionisten lieferte
den Malern Vorlagen, die diese
für ihre Gemälde verwendeten.

Charles Famin
France

*Village in the Forest
of Fontainebleau*
1870 ca.
Albumen print from
glass negative
257 x 189 mm

In 1986, Françoise Heilbrun,
curator of the Musée d'Orsay in
Paris, described Famin as
"the most noteworthy
landscape photographer of his
time". The body of his work
dates from the end of the
1860's until the mid 1880's, and
depicts primarily the
countryside around
Fontainebleau.

A contemporary of the
impressionists, Famin often
supplied the painters with
photographs which they used
as motifs in their work.

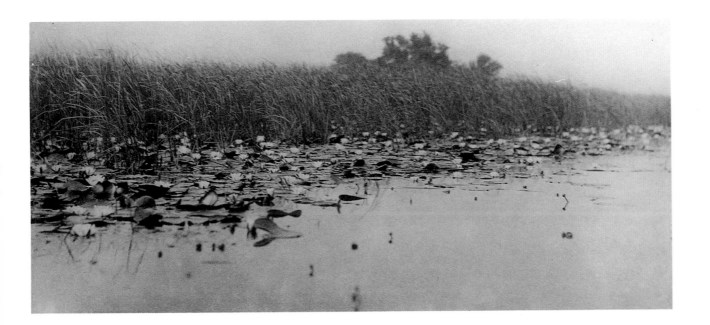

Peter Henry Emerson
England, 1856-1936

Wasserlilien
1886
Platin-Abzug vom
Gelatin-Trockenplatten-Negativ
124 x 284 mm

Als Sohn einer Engländerin und eines Amerikaners wurde Peter Henry Emerson in Kuba geboren. Als sein Vater 1869 starb, übersiedelte Emerson nach England, um Medizin zu studieren. 1882 begann er zu photographieren. 1884, ein Jahr vor den letzten Examina als Mediziner, übersiedelte Emerson von London nach Suffolk; die Darstellung der ostenglischen Landschaft und ihrer Bewohner wurde zum charakteristischen Motiv seines photographischen Schaffens.

Peter Henry Emerson
England, 1856-1936

Water Lilies
1886
Platinum print
from a gelatin dry-plate
negative
124 x 284 mm

Emerson was born in Cuba to an American father and an English mother. When his father died in 1869, he returned to England to study medicine. Emerson first began working with a camera in 1882. In 1884, a year before taking his final medical examinations, he moved from London to Suffolk. The East Anglian countryside and its inhabitants became the subject matter characteristic of Emerson's photographic work.

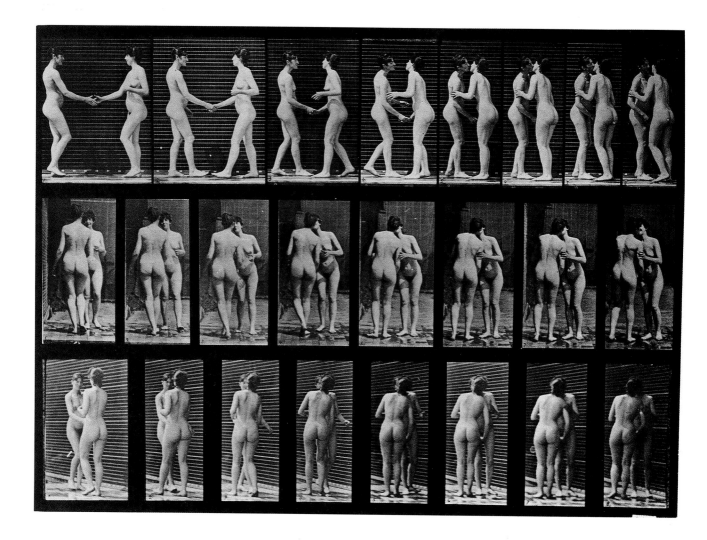

Eadweard Muybridge
England, 1830-1904

Zwei sich grüßende Frauen
1887
Lichtdruck
228 x 305 mm

Als Repräsentant der Londoner Printing and Publishing Company gelangte Eadweard Muybridge in die Vereinigten Staaten von Amerika. 1868 war er offizieller Photograph beim amerikanischen Militär im kurz zuvor von den USA erworbenen Alaska. Von 1868 bis 1873 machte Muybridge über 2000 Aufnahmen im amerikanischen 'Far West', im Gebiet der Rocky Mountains und der pazifischen Küste. 1872 sollte Muybridge eine Wette klären: es ging um die Bewegungsabläufe eines trabenden Pferdes. Bei kürzester Verschlußzeit gelang ihm nur ein schwaches Bild, doch fünf Jahre später war er erfolgreich: Mehrere in Reihe stehende Kameras mit mechanisch gekoppelten Verschlüssen machten einen klaren Nachweis der Bewegungsabläufe des Pferdes möglich. Seine Arbeit wurde in der Folge zum bedeutendsten Beitrag der Studien von Bewegungsabläufen bei Mensch und Tier.

Eadweard Muybridge
England, 1830-1904

Two Women Greeting
1887
Collotype
228 x 305 mm

As a representative of the London Printing and Publishing Company, Muybridge came to The United States and learned photography in San Francisco from daguerreotypist, Silas Selleck in the early 1860's. In 1868, he was the official photographer accompanying the American military in recently purchased Alaska. He took over 2,000 photographs of the American Far West between 1868 and 1873. In 1872, Muybridge was comissioned to settle a wager regarding the position of a trotting horse's legs. Using the fastest shutter available, Muybridge was able to provide only the faintest image. He was more successful five years later when, employing a battery of cameras with mechanically tripped shutters, he showed clearly the stages of the horse's movement, Muybridge was the most significant contributor to the early study of human and animal locomotion.

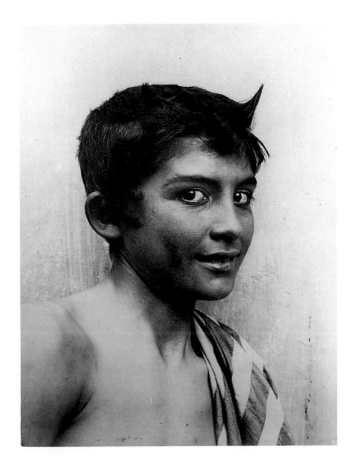

Wilhelm von Gloeden
Deutschland, 1856-1931

"Il Fauno"
Ca. 1900
Albuminpapier-Abzug vom
Glas-Negativ
221 x 168 mm

Wilhelm von Gloeden verließ
seine Heimat Deutschland und
ließ sich im sizilianischen
Taormina nieder, wo er bis zu
seinem Tode lebte. Ende des
19. Jahrhunderts wurde er
professioneller Photograph,
der bald eine breite Aufmerk-
samkeit auf sich zog. Sein
Zuhause in Taormina wurde zu
einer Art Mekka vieler
prominenter Zeitgenossen.

Wilhelm von Gloeden
Germany, 1856-1931

"Il Fauno"
1900 ca.
Albumen print from glass
negative
221 x 168 mm

In 1877, Wilhelm von Gloeden
left his native country, Germany,
for Taormina, Sicily. Here he
remained, until his death. He
became a professional photo-
grapher in the last decade of
the nineteenth century and
soon won the wide-spread
recognition of his contem-
poraries. His house in Taormina
became a kind of cultural
Mecca for many prominent
personalities of the day.

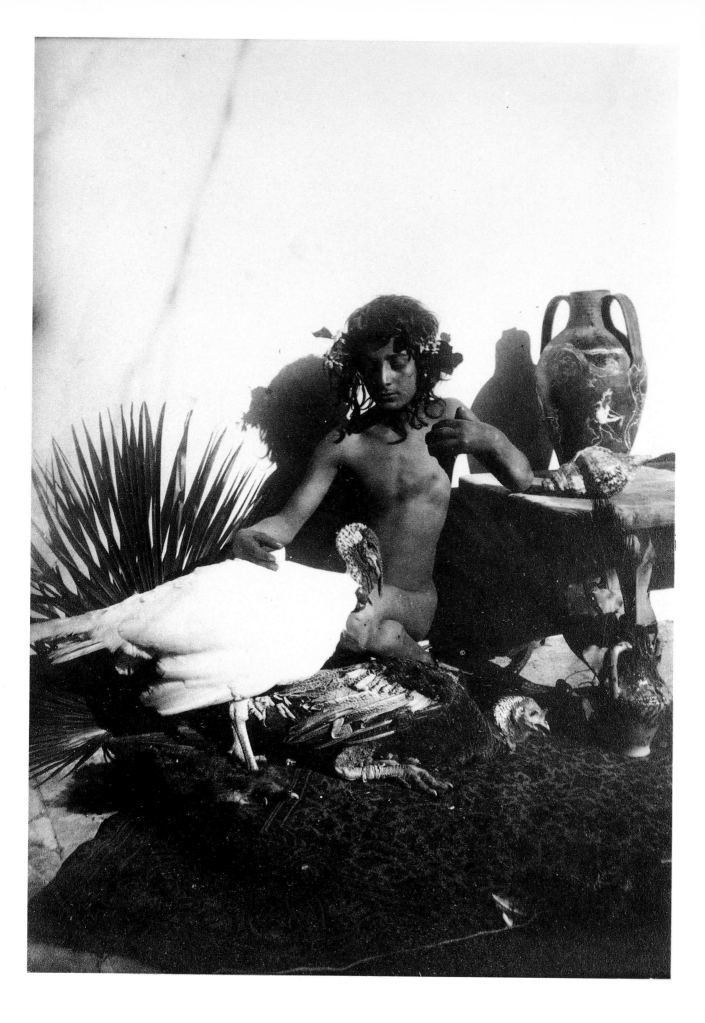

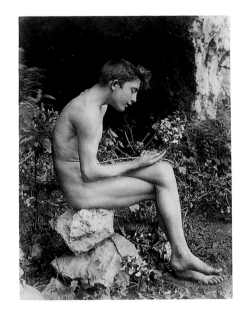

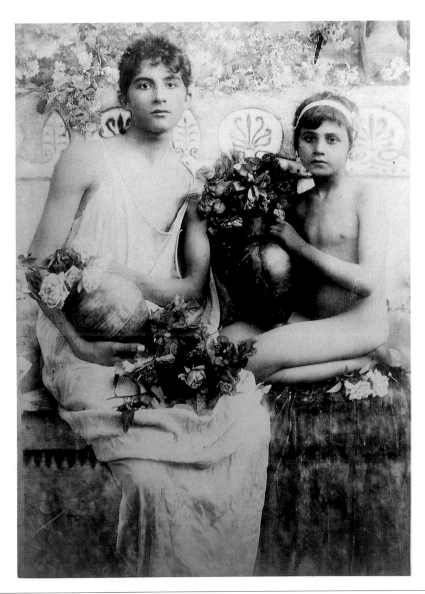

Wilhelm von Gloeden
Deutschland, 1856-1931

Nackter Junge mit Truthahn
Ca. 1895
Albuminpapier-Abzug vom
Glas-Negativ
171 x 122 mm

Wilhelm von Gloeden
Deutschland, 1856-1931

Nackter Junge mit Blumen
1900
Albuminpapier-Abzug vom
Glas-Negativ
171 x 122 mm

Wilhelm von Gloeden
Deutschland, 1856-1931

Zwei Jungen mit Rosenvasen
Ca. 1903
Platin-Abzug vom
Glas-Negativ
365 x 265 mm

Wilhelm von Gloeden
Germany, 1856-1931

Naked Boy with Turkey
1895 ca.
Albumen print from glass
negative
171 x 122 mm

Wilhelm von Gloeden
Germany, 1856-1931

Naked Boy with Flowers
1900
Albumen print from glass
negative
171 x 122 mm

Wilhelm von Gloeden
Germany, 1856-1931

Two Boys with Rose Vases
1903 ca.
Platinum print from glass
negative
365 x 265 mm

E.J. Constant Puyo
Frankreich, 1857-1933

Junge Frau im Sessel
1903
Ozotypie
221 x 168 mm

E.J. Constant Puyo, ein General-stabsoffizier, begann 1889 zu photographieren. Als er sich zur Ruhe setzte, widmete er seine Zeit ausschließlich der Photographie, vorwiegend den technischen Fragestellungen bei der Entwicklung von Linsen und der Entwicklung des Öl/Gummi-Druckes.

Heinrich Kühn
Deutschland, 1866-1944

Edeltrude, die Tochter des Photographen
Ca. 1903
Gummidruck
415 x 320 mm

Heinrich Kühn war Mitglied des Kamera Klubs in Wien, dem nach Hamburg wichtigsten deutschsprachigen Zentrum für künstlerische Photographie. Zusammen mit Hans Watzek und Hugo Henneberg verbesserte er den Gummibichromat-Prozeß.

E.J. Constant Puyo
France, 1857-1933

Young Woman in Armchair
1903
Green pigment ozotype
221 x 168 mm

E.J. Constant Puyo, a General Staff Officer, began taking photographs in 1889. After his retirement, he dedicated himself exclusively to photography, concerning himself mainly with the technical problems involved in the development of the lens, and with the improvement of the oil and gum print process.

Heinrich Kühn
Germany, 1866-1944

The Photographer's Daughter, Edeltrude
1903 ca.
Gum bichromate print
415 x 320 mm

Kühn was a member of the Camera Club in Vienna (after Hamburg, the second most important centre for artistic photography), and there he met Hans Watzek and Hugo Henneberg with whom he collaborated on studies to improve the multiple gum-bichromatic process.

124 **Oskar Suck**
Deutschland

Der Marktplatz in Karlsruhe
1886
Albuminpapier-Abzug vom
Glas-Negativ
168 x 214 mm

Biographische Einzelheiten
Oskar Sucks sind unbekannt. Er
lebte und arbeitete in Karlsruhe.
In einem Register des „Vereins
zur Förderung der Photographie"
(Berlin) wird darauf hingewiesen,
Sucks Momentaufnahmen von
sich grüßenden Menschen und
Marktplatzszenen seien von
„überraschender Wahrhaftigkeit"
(11.2.1887).

Oskar Suck
Germany

The Market Square in Karlsruhe
1886
Albumen print
from glass negative
168 x 214 mm

Details of Suck's life are
unknown. A register kept by the
"Society for the Advancement
of Photography" reveals only
that he lived and worked in
Karlsruhe. An entry from this
register on February 2nd, 1887
reads, "various scenes, such as
people greeting one another,
barrow-traders and market
women are of surprising
authenticity".

Eugène Atget
Frankreich, 1857-1927

*„Enseigne 8 Rue Clement,
6e arr. 4463", Paris*
1902
Albuminpapier-Abzug vom
Glas-Negativ
220 x 177 mm

Jean Eugène Auguste Atget
war einer der ersten, die die
Photographie als Mittel zur
Dokumentation sozialer
Verhältnisse nutzte und wurde
zu einem der führenden
Exponenten seines Fachs.
Seine Aufnahmen von Paris
sind das vielleicht vitalste
Stadtbild überhaupt. Atget
begann mit vierzig Jahren;

in dreißig folgenden Jahren
entstanden über zehntausend
Photographien, aufgenommen
mit einer altmodischen
18 x 24 cm-Kamera auf einem
hölzernen Dreifuß, gesehen
durch rektilineare Linsen.

Eugène Atget
France, 1857-1927

*"Enseigne 8 Rue Clement,
6e arr. 4463", Paris*
1902
Albumen print from
glass negative
220 x 177 mm

Jean Eugène Auguste Atget,
who was among the first to use
photography for social
documentation, has come to
be regarded as one of
the medium's major figures.
His images of Paris are perhaps
the most vived record of a city
ever produced. Atget began
photographing at the age of
forty. Over a span of thirty years,

he was to take over 10,000
photographs of Paris, using
obsolete equipment: an
18 x 24 cm bellows camera,
rectilinear lenses, a wooden
tripod and a few plate holders.

Register/Index